Zen & Oriental Art

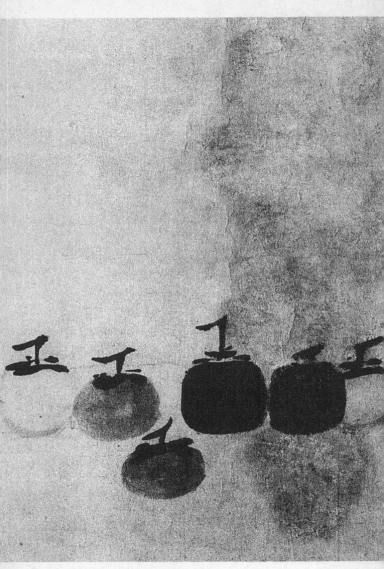

1 *(Frontispiece)*. "Persimmons." Mu-ch'i.
Collection of the Daitoku-ji, Kyoto.

Zen &

Oriental Art

■

by Hugo Munsterberg

■

CHARLES E. TUTTLE COMPANY
Rutland · Vermont : Tokyo · Japan

Published by the Charles E. Tuttle Company, Inc.
of Rutland, Vermont & Tokyo, Japan
with editorial offices at
2-6, Suido 1-chome, Bunkyo-ku, Tokyo 112

LCC Card No. 65-17589
ISBN 0-8048-1902-5

First edition, 1965
First paperback edition, 1993
Second printing, 1994

Printed in Japan

To BENJAMIN ROWLAND
who introduced me to Buddhist Art

Table of Contents

LIST OF ILLUSTRATIONS 9

PREFACE 11

1. The Origin and Nature of Zen Buddhism 13

2. The Introduction and Development of Zen in
 Japan 23

3. Chinese Painting under Ch'an Inspiration 31

4. Zen Painting in Japan 61

5. Cha-no-Yu and Zen 91

6. Zen in Japanese Architecture 101

7. Zen in Japanese Gardens 127

8. Zen and Modern Art 141

NOTES 149

BIBLIOGRAPHY 151

INDEX 153

■ List of Illustrations

1 *(Frontispiece)*. "Persimmons," Mu-ch'i *page 2*
2. "Bodhidharma," Mu-ch'i *41*
3. "Monkeys," Mu-ch'i *42*
4. "Pu-tai," Liang Ka'i *43*
5. "Patriarch Hui-nêng Tearing Up the Sutras," Liang K'ai *43*
6. "A Mountain Village in Clearing Mist," Yü-chien *44, 45*
7. "A Mountain Village in Clearing Mist" (detail), Yü-chien *46, 47*
8. "Tan-hsia Burning the Buddha Statue," Yin-t'o-lo *48, 49*
9. "Han-shan" and "Shih-tê" (pair of scrolls), Yin-t'o-lo *50*
10. "Zen Monk in Meditation," attributed to Yen-hui *51*
11. "Bodhidharma," unknown artist *52*
12. "The Four Sleepers," Mokuan *73*
13. "Kanzan," Kao *74*
14. "Muso Kokushi," Muto Shui *75*
15. "Shoichi Kokushi," Cho Densu *76*
16. "Ikkyu," Bokusai *77*
17. "Catching a Catfish with a Gourd," Josetsu *78, 79*
18. "Kanzan and Jittoku," Shubun *80*
19. "Hui-k'o Offering His Arm to Bodhidharma," Sesshu *81*
20. "Landscape," Sesshu *82*
21. "Cormorant," Niten (Miyamoto Musashi) *83*
22. "Rinzai, Daruma, and Tokusan" (triptych), Dasoku *84, 85*
23. "Daruma," Hakuin *86*
24. Self-portrait, Hakuin *87*

25. "Fukurokuju," Sengai *88*
26. Seto tea caddies *109*
27. Red Raku tea bowl: "Haya-fune" *109*
28. White *temmoku* tea bowl *110*
29. Black Raku tea bowl: "Shunkan" *110*
30. Gray Shino cake plate *111*
31. Oribe cake plate *111*
32. Karatsu bowl *112*
33. Old Bizen tea bowl *112*
34. Togudo, Ginkaku-ji *113*
35. Shariden, Engaku-ji *114*
36. Abbot's residence, Daisen-in, Daitoku-ji *115*
37. Ginkaku-ji *116*
38. Entrance to tearoom, Koto-in *117*
39. Tearoom, Koho-an, Daitoku-ji *118*
40, 41. Stone garden, Ryoan-ji *119, 120*
42. Rock garden, Daisen-in, Daitoku-ji *121*
43. Garden, Ginkaku-ji *122*
44. Stone lantern and basin, Koho-an, Daitoku-ji *123*
45. Stone path and gate, Kanden Tea House *124*
46. Shokin-tei, Katsura Detached Palace *125*
47. Tearoom with view of garden, Koho-an, Daitoku-ji *126*
48. "Night," Mark Tobey *135*
49. "Black Waves," Morris Graves *136*
50. "Still Life," Julius Bissier *137*
51. "Ragara" and "Monju," Shiko Munakata *138*
52. "Dynasty," Kenzo Okada *139*
53. Daruma doll *140*

■ Preface

THIS BOOK represents an attempt to explore the relationship between Zen Buddhism and the visual arts in traditional China and Japan and in the world of today. Though many authors have suggested that such a relationship does exist, most of them have failed to document their contention. The present study has tried to be as detailed as possible, pointing to actual influences and referring to specific works of art. No such undertaking would have been possible without the contributions of Daisetz Suzuki, the famous Zen abbot, and Alan W. Watts, the Western world's chief interpreter of Zen, to both of whom the author wishes to express his indebtedness.

Thanks are also due to the museums, Buddhist temples, and private collectors who were generous enough to permit the reproduction of their works and the photographers who supplied the pictures. Furthermore, the author wishes to express his indebtedness to the writers quoted in the text, to Miss Mioko Onchi, who helped secure illustrative material in Japan, and above all to his wife who, as on many previous occasions, went over the manuscript with infinite care and offered many helpful suggestions.

HUGO MUNSTERBERG

New Paltz

The Origin & Nature of Zen Buddhism

IT IS IMPOSSIBLE to define Zen in words. The Zen masters insisted that what can be expressed verbally is not Zen, just as centuries earlier Lao-tzu had said, "If the Tao could be comprised in words, it would not be the unchangeable Tao."[1] Sakyamuni himself, to whom legend attributes the origin of Dhyani Buddhism, is supposed to have pointed at a bouquet of flowers when he was questioned about the nature of ultimate reality. "Not a word came out of his mouth. Nobody understood the meaning of this except the old venerable Mahākāśyapa, who quietly smiled at the master, as if he fully comprehended the purport of this silent but eloquent teaching on part of the Enlightened One. The latter, perceiving this, opened his gold-tongued mouth and proclaimed solemnly: 'I have the most precious treasure, spiritual and transcendental, which this moment I hand over to you, O venerable Mahākāśyapa.' "[2] Ever since that day, according to Zen legend, there has existed a third tradition, Dhyani or meditative Buddhism (known as Ch'an in China and Zen in Japan) which stands apart from the two main bodies of Buddhism, the Hinayana, or Small Vehicle school, which still flourishes in Ceylon, Thailand, and Burma, and the Mahayana or Great Vehicle school, which has been dominant in China and Japan.

The first event in the history of Zen Buddhism which

can be documented with a fair amount of certainty is the arrival in China in A.D. 527 of the Indian monk Bodhidharma, better known by his Japanese name of Daruma, who is said to have been the twenty-eighth patriarch in the line of descent from Buddha's disciple Kasyapa. The Liang dynasty emperor Wu, upon hearing of the great teacher's arrival, at once summoned him to his court at Nanking, but the encounter must have been a disappointment to the emperor, who could not have enjoyed the answers that the monk gave to his questions. When the Son of Heaven asked if he had acquired merit by building temples, distributing scriptures, and giving alms, Bodhidharma replied, "Not at all." Upon being asked in what true merit consisted, the teacher said, "In the obliteration of Matter through Absolute Knowledge, not by external acts." Finally, when asked who he who had come before the imperial throne was, the patriarch replied, "I do not know."[3] It is reported that Bodhidharma thereupon left the capital and established himself in a small country temple in northern China where he sat contemplating a wall for nine years, during which period disciples came from all over China to study with him. Little is known about his end. Some records say that he returned to India, others that he died in China, but all agree that he lived to a venerable old age. Considered the first of the Chinese Ch'an patriarchs, he had many followers, among whom Hui-k'o was the most significant.

The next really important figure in the development of Dhyani Buddhism was the sixth patriarch, Hui-nêng (in Japanese, Eno), who lived from 637 to 713 and who must be looked upon as the true founder of what we call Ch'an or Zen Buddhism. A man of the T'ang period, he lived during the golden age of Chinese culture and was deeply versed not only in Indian religious doctrine but also in native Chinese philosophy. The essence of Hui-nêng's teaching consisted of looking into one's own Buddha nature, since only there could one find the *prajna,* or supreme wisdom. According to Hui-nêng, what was necessary for enlightenment was not *dhyana,* or contemplation, but the return to one's true being. When a monk

asked him for instruction, he replied, "Show me your original face before you were born." Unlike the Indian sages, who thought in abstract philosophical terms, his approach was always direct and specific, in keeping with the Chinese tradition. Upon being asked about his teaching, he replied, "My master had no special instruction to give, he simply insisted upon the need of our seeing into our own nature through our own efforts; he had nothing to do with meditation, or with deliverance. To take hold of this non-duality of truth is the aim of Zen. The Buddha-Nature of which we are all in possession, and the seeing into which constitutes Zen, is indivisible into such opposition as good and evil, eternal and temporal, material and spiritual. To see dualism in life is due to confusion of thought; the wise, the enlightened, see into the reality of things unhampered by erroneous ideas."[4]

Perhaps the best summary of Zen teaching is found in the following *gatha* or sacred lines, which have been attributed to Bodhidharma himself but which probably date from several centuries later.

"A special transmission outside the doctrinal teaching,
No dependence on letters or words,
Pointing directly at the Mind in every one of us,
And seeing into one's Nature, whereby one attains Buddhahood."

All the essential features of Zen Buddhism are contained in these lines. First, Zen exists outside the traditional doctrines of Buddhism, having little to do either with religion or philosophy as they are usually understood. It stands apart from all other sects, and in a way is closer to the experiences of mystics in general than to the followers of Sakyamuni or the worshippers of Amitabha, the Buddha of the Western Paradise. Second, in contrast to the other sects, the Zen masters paid little attention to the sacred scriptures of Buddhism, of which the Buddhist canon includes no less than five thousand volumes, some attributed to Gautama himself, others to later disciples and various unknown authors. The reason that Zen turned away from the Scriptures is that it was felt that real

knowledge could never be found through study but only in awakening to one's own nature. This leads to the third and fourth points: that the Mind, the Ultimate Essence, the Tao, or, as the Zen masters would say, the Buddha, is not in Paradise, or the temple, or the sutras, but in our heart, and only by looking into the depth of our essential self—after first stilling the desires and tensions of our outward life—can we find peace and become a Buddha. There is a striking parallel between this doctrine and that of other mystic sects. What the Dhyani Buddhist calls the Buddha nature, or Zen, is similar to what the Christian mystic calls God, Lao-Tzu and his followers Tao (a term also used by Zen Buddhists), the Hindus Brahman, or Martin Buber, the great contemporary Jewish mystic, the Ground of All Being.

The question of Zen's origin and its relationship to Buddhism has been taken up by many authorities and given different answers, depending upon the author's background and point of view. Yet everyone agrees that Zen—to use Alan Watts's expression—has a peculiar flavor and is unlike anything found in India. As Sir Charles Eliot says, "Zen, as far as our knowledge of its history goes, is a Far Eastern religion, and it is not easy to say anything definite about its connection with India. Even if the Lankâvatâra-sûtra expresses its main doctrines, it expresses them in a thoroughly Indian way, and the idea of not depending on books and letters is not at all Indian."[5] No doubt there are parallels between certain aspects of Indian thought and Zen, but, interestingly enough, these are found not so much in Buddhist scriptures as in the Upanishads, with their strong mystic tone. As other authors, such as Professor Arthur Wright, have observed, Zen may be looked upon as "the reaction of a powerful tradition of Chinese thought against the verbosity, the scholasticism, the tedious logical demonstrations, of the Indian Buddhist texts."[6] Since the Chinese tradition was a humanistic one which emphasized common sense rather than abstract philosophical speculation, Ch'an, with its directness, its simplicity, and its distrust of intellectual analysis, was very much in keeping with

Chinese thought. In fact, during the Late Chou and Han periods, long before Dhyani Buddhism was introduced from India, the Chinese had already developed their own form of mysticism in Taoism. Christmas Humphreys, the president of the Buddhist Society of London, puts it aptly when he says that although Zen was not a Mahayana doctrine, Mahayana was a prelude to Zen's birth, "for it was the Chinese genius working on the raw material of Indian thought which, with contributions from Confucian and Taoist sources, produced, with Bodhidharma as midwife, the essentially Chinese School of Ch'an, or as the Japanese later called it, Zen Buddhism."[7]

The unique feature of Ch'an Buddhism, if it is contrasted with the other sects, is its emphasis upon what the Japanese call *satori*, the immediate experience of ultimate truth, a state of consciousness in which the duality of the world has ceased to exist. All the traditional paraphernalia of Buddhism—the sacred texts, the worship of images, the chanted ritual, the very organization of the temples—are considered of no importance. A famous Zen painting by the great thirteenth-century Chinese painter Liang K'ai shows one of the patriarchs laughing as he tears up the sutras, for he knows that the true Buddha is not found in any book but in our own consciousness. Ananda Coomaraswamy characterized Zen Buddhism very well when he said, "This phase of Mahayana is little determined by special forms, and can scarcely be said to have any creed other than that the kingdom of heaven is in the heart of man."[8] This new awareness reached through the attainment of *satori* can be achieved quite suddenly, not only during contemplation, or while undergoing monastic discipline, but almost anywhere. Stories are told of *satori* being attained while crossing a river, viewing plum blossoms, sweeping the ground, or chopping wood; yet the nature of the experience is always the same. As the sixth patriarch, Hui-nêng, says in *The Sutra of Wei Lang*, "Prajñā (the transcendental Wisdom) does not vary with different persons; what makes the difference is whether one's mind is enlightened or deluded. He who does not know his own Essence of Mind, and is under the delusion

that Buddhahood can be attained by outward religious rites is called slow-witted. He who knows the teaching of the 'Sudden' School and attaches no importance to rituals, and whose mind functions always under right views, so that he is absolutely free from defilements or contaminations, is said to have known this Essence of Mind. . . . It is upon this principle that Prajñā is latent in every man that the doctrine expounded in these books is established."[9]

One of the main techniques of the Ch'an monks, and certainly the most original, was the use of the *koan,* a kind of riddle which the master asked his disciples. This practice was invented in China during the tenth century and became very popular, especially in Japan, where it was highly developed as a method of instruction. The Zen school known in Japan as the Rinzai sect, which the tenth-century Chinese monk Lin-chi had founded, emphasized both sudden enlightenment, which would come like a flash, and the use of *koan.* The most famous of these riddles was the *koan* posed by the celebrated eighteenth-century Japanese Zen master Hakuin, who, holding up his hand, said, "What sound does the clapping of one hand make?" Another famous *koan* asks, "When your corpse is cremated and the ashes are scattered to the winds, where are you?" The most puzzling of all, perhaps, is the following. "When a master was asked whether or not the dog has Buddha-nature, he answered, 'Mu!' (*wu* in Chinese), meaning 'No!' What does this 'mu' really mean?"[10]

The solution to these strange questions is never to be thought of in rational or philosophical terms but in intuitive understanding. In fact, verbal answers were not necessary; a spontaneous action, often taking an apparently foolish or even a bizarre form, was much preferred. The aim at all times was to achieve *satori,* to free oneself from the delusions of the outer world, to discover the still voice within. To employ Christian terminology, the goal was to attain that peace which passes understanding, to lose oneself so as to find oneself, for as long as one thinks as the world thinks, one will never discover the wisdom of the self.

Another characteristic that sets Zen apart is its emphasis

upon ordinary labor. Although meditation was an essential part of Zen, and special halls called *zendo* were built for the monks to meditate in, manual work was regarded as of the utmost importance. Not only the monks but the master himself participated in cleaning, sweeping, washing, cooking, farming, and the monthly round of begging. A famous Zen saying is that of the Chinese Zen layman Pang Chü-shih of the T'ang dynasty, who exclaimed, "How miraculous, how wonderful! I draw water, I carry wood." Here again the Zen emphasis on simplicity is similar to the Taoist ideal expressed by Chuang-tzu when he said, "I would have to strip away not your fine fur only, but every impediment of the body, scour your heart until it is free from all desire, and travel through desolate wilds. For to the south there is a place called the Land Where Tê Rules. Its people are ignorant and unspoiled, negligent of their own interests, and of few desires. They know how to make, but do not know how to hoard. They give but seek no return. The suitabilities of decorum, the solemnities of ritual are alike unknown to them. They live and move thoughtlessly and at random, yet every step they take tallies with the Great Plan. They know how to enjoy life while it lasts, are ready to be put away when death comes. I would have you leave your kingdom and its ways, take Tao as your guide and travel to this land."[11] The fifth patriarch, Hung-jên, who presided over five hundred monks at the Yellow Plum Mountain, did not choose as his successor one of the monks who were serving under him but an obscure, uneducated lay brother who worked in the bakery and who, the master felt, had a better understanding of the true nature of Zen than any of the other members of the community.

Although the beginnings of Ch'an Buddhism may be traced back to the fourth century,[12] it did not assume a major role in China until the T'ang period (618–908). Fully developed under the sixth patriarch Hui-nêng, it became the dominant form of Chinese Buddhism and during the later half of the eighth century, it was declared the orthodox school by imperial commission.[13] Emphasizing the vernacular of the period and using a pragmatic

approach that appealed to the Chinese mind, Ch'an was able to win a pre-eminence that, especially among artists and intellectuals of the Far East, it has enjoyed ever since. Another factor that helped the growth of Ch'an Buddhism was the brief but vigorous persecution of Buddhism by the Taoist emperor Wu-tsung during the late T'ang period. Temples and monasteries were torn down, images and sutras destroyed, and the monks forced to return to secular life—a catastrophe which Ch'an, with its freer approach, could withstand better than the older, more conventional sects. The famous Japanese pilgrim Ennin, who visited the Chinese mainland from 838 to 847, reports meeting Ch'an monks on several occasions, but he was apparently put off by their strangeness, for he says that they were "extremely unruly men at heart."[14] Zen now entered a long period of popular as well as official favor and, during the Sung period (960–1279), won a wide following among all classes of people. However, as is often the case, success brought its own dangers, for the quality both of Ch'an thought and of monastery life began to suffer, and what had once been a bold, new faith now became an established institution, with the sayings of the great T'ang masters collected into anthologies. Although Ch'an Buddhism played a role during the Yüan (1280–1368) and the Ming (1368–1644) periods, it gradually lost its vigor and today is no longer important in the cultural life of China.

It is difficult to overestimate the influence of Ch'an on the culture of China, especially during the Sung period, and above all on that of Japan. Painting, calligraphy, flower arrangement, the tea ceremony, landscape gardening, and architecture came under its influence. Not all of this was to the good—the pre-eminence of Ch'an Buddhism had negative effects on Buddhist sculpture and traditional Buddhist painting, since Ch'an monasteries had no need of the icons which were used by the rival sects. So great was the influence of Ch'an teachings that Taoists and even Confucianists felt the impact of its thinking. Alan Watts, in describing the effect of Ch'an Buddhism on the culture of the time, puts it very well when he says, "After the per-

secution of Chinese Buddhism in 845, Zen was for some time not only the dominant form of Buddhism but also the most powerful spiritual influence in the growth of Chinese culture. This influence was at its height during the Southern Sung dynasty (1121–1279), and during this time the Zen monasteries became leading centers of Chinese scholarship. Lay scholars, Confucian and Taoist alike, visited them for periods of study, and Zen monks in turn familiarized themselves with Chinese classical studies. Since writing and poetry were among the chief occupations of Chinese scholars, and since the Chinese way of painting is closely akin to writing, the roles of scholar, artist, and poet were not widely separated. The Chinese gentleman-scholar was not a specialist, and it was quite against the nature of the Zen monk to confine his interests and activities to purely 'religious' affairs. The result was a tremendous cross fertilization of philosophical, scholarly, poetic, and artistic pursuits in which the Zen and Taoist feeling of 'naturalness' became the dominant note."[15]

■ CHAPTER TWO

The Introduction & Development
of Zen in Japan

TRADITION has it that Ch'an Buddhism was introduced
into Japan as early as the Nara period (710–94), but little
is known about this, and one must conclude that it met
with no success. The first well-documented event occurs
in the early ninth century when a Chinese monk, known
in Japan as Giku, preached in the capital city of Heiankyo,
the present-day Kyoto. Apparently he was treated well,
for the emperor and the empress received him in audience,
but his mission was not successful, and he returned to his
native country without having made any notable con-
versions. A few years later, about 858, the Japanese monk
Egaku is said to have visited China, where he learned
about Ch'an Buddhism, but when he tried to introduce
it to Japan he was unable to win any adherents. It may
seem strange that Zen, which was to have such an ex-
traordinary influence on Japanese culture, should have
made so poor a beginning, yet it must be remembered
that the situation in Japan was very different from that in
China, with its ancient and highly sophisticated culture
in which the Taoists had prepared the way for the ac-
ceptance of Ch'an. Japan, on the contrary, had remained
primitive until the sixth century, when Buddhism and
Confucian learning were introduced from Korea and
China. Furthermore, the established Buddhist sects at the
capital, such as Tendai and Shingon, would naturally

have opposed any rival and thus resisted the establishment of a new doctrine.

The real founder of the Japanese school of meditative Buddhism was the monk Eisai (1141–1215), who was born in western Japan but was educated at the famous monastery on Mount Hiei not far from Kyoto which was the center of the Tendai sect. In 1168 he made a brief trip to the Chinese mainland to visit the mother house of the Tendai sect at T'ien T'ai. Two decades later Eisai embarked upon a second pilgrimage during which he hoped to visit India, the homeland of Buddhism, but he never got beyond China, where he remained for several years. It was during this stay that he came under the influence of Ch'an, which was extremely popular in Sung China. In 1191 he returned to Japan as a full-fledged master of the Rinzai school of Zen Buddhism, named after the sect's founder, the Chinese priest Lin-chi. Along with Zen, Eisai also brought back tea, which at first was used both as a medicine and as a stimulant to help keep the monks awake during their meditations. Upon his return to Japan, Eisai established a Zen monastery in Kyushu in the town of Hakata. Soon after this, he moved to Kyoto, where in 1202 he founded the Zen temple of Kennin-ji at the request of the Shogun Yoriie, who also honored him with the highest ecclesiastical title, that of Dai-Sojo. His success was even more marked with the rulers of the Kamakura regime, the Minamoto and Hojo clans, and eventually he left the rather hostile atmosphere of Kyoto, where the older sects resisted his activities, and established himself in the new capital of Kamakura, not far from present-day Tokyo. Here he was extremely successful, and it was due to his influence that the warrior aristocracy of the eastern capital embraced Zen. Its direct, practical approach appealed to the samurai, who were not given to esoteric doctrines or learned disputations, preferring the self-reliance, austerity, and severe discipline of Zen, which corresponded to the warrior code.

The second great Zen figure in Japan was Eisai's pupil Dogen, who lived from 1200 to 1253. An aristocrat by birth, Dogen had been trained for a political career but

chose instead to take up a religious life. He went to Mount Hiei and Miidera for instruction, but he did not find what he was looking for until he became a pupil of Eisai and, following his master's example, went to China, where he stayed from 1223 to 1228, visiting Ch'an monasteries and studying Buddhist doctrines. Upon his return to Japan, he took up residence at Kennin-ji in Kyoto, but since he was unwilling to become involved in the worldly life of the capital, he soon retired to the provinces and built a monastery not far from Fukui which he called Eihei-ji and which is still regarded as the headquarters of the Zen school introduced by Dogen and known as Soto (Ts'ao-tung in Chinese). In contrast to the Rinzai sect established by his teacher Eisai, which stressed sudden enlightenment and the use of *koan,* the Soto sect emphasized meditation, spiritual discipline, and moral conduct.

Dogen's importance in the development of Japanese Buddhism goes beyond his influence as a teacher, for he was also a remarkable writer whose *Shobo Genzo Zuimonki* (Treasure of the Eye of the True Doctrine) is one of the most celebrated Buddhist classics in Japan. The following passage gives an idea of the flavor as well as the content of this work. "In the pursuit of the Way (Buddhism) the prime essential is sitting *(zazen)* . . . By reflecting upon various 'public cases' *(koan)* and dialogues of the patriarchs, we may perhaps get the sense of them, but it will only result in one's being led astray from the way of the Buddha, our founder. Just to pass the time in sitting straight without thought of a question, without any sense of achieving enlightenment—this is the way of the Founder. It is true that our predecessors recommended both the *koan* and sitting, but it was sitting that they particularly insisted upon. There have been some who attained enlightenment through the test of the *koan*, but the true cause of enlightenment was the merit and effectiveness of sitting. Truly the merit lies in the sitting."[16]

By the middle of the thirteenth century Zen was firmly established as the dominant Buddhist sect of Japan which had a particular appeal to the educated classes and the warriors, while the various Amida sects and Nichiren's

teachings were popular with the common people. Among the Zen temples, the most famous were the so-called Go-zan or Five Great Temples, three of them in Kamakura—namely Enkaku-ji, Kencho-ji, and Jufuku-ji—and two in Kyoto, namely Kennin-ji and Tofuku-ji. Numerous Zen masters were active in this period, and their sayings as well as various anecdotes about them were collected and passed down through the centuries as a precious part of the Zen heritage. The most important and one of the greatest figures in the political history of Japan was Muso Soseki (1275 to 1351), who is better known as Muso Kokushi, or Muso, the National Master. His influence with the rulers of the day was so great that the Shogun Ashikaga Takauji built the famous Tenryu-ji monastery for him. In fact, his relationship to the worldly rulers was so close that he first acted as advisor to the Hojo regents in Kama-kura, then to the Emperor Go-Daigo, who was trying to reassert the imperial power, and finally to the Ashikaga shoguns, who had replaced the Kamakura rulers. He was also responsible for persuading the Japanese government to send the first official mission in five hundred years to China in 1325, an event which was to have a tremendous impact on the cultural life of Japan. That Zen became the official Buddhist sect during the Ashikaga regime (1333–1573) was to a large extent due to men like Muso Koku-shi, who gained a position of importance for the Zen masters not only in the religious life of Japan but also in its political councils.

The Ashikaga or Muromachi period was one which combined political and military strife with a cultural florescence which was centered in the Zen monasteries. In fact, it has been suggested that since conditions in the country were so chaotic, men of learning and artists and writers took refuge in the monasteries in order to pursue their work in peace. Even the Ashikaga shoguns were allied with Zen, and one of the most famous, Yoshi-mitsu (1358–1408), retired from public life at the age of thirty-eight to become a Zen monk under the name of Doyu. His grandson Yoshimasa (1435–90) followed his example and became a Zen monk at the age of forty.

The influence of Zen was not confined to cultural and religious life, for the priests also interested themselves in secular affairs. They acted as advisors to the shoguns, especially in matters of foreign trade, and every overseas delegation was led by a Zen monk. Education also came under their control, since they ran the temple schools or *terakoya,* and the Ashikaga college, which during the fifteenth century became the greatest center of learning in Japan, was headed by a Zen priest. At the same time the old Zen temples founded during the Kamakura period continued to expand, and new monasteries were built, like Nanzen-ji, the center of the Rinzai sect in Kyoto.

The astonishing influence of the Zen monks was not based on their religious teaching alone; among other reasons, the most important was probably their close contact with China. When the Mongols defeated the Southern Sung rulers in 1279, many Chinese monks fled to Japan, and later, after the native Ming dynasty had come to power in 1368 and relations with China had been restored, Zen monks headed the trade missions and were responsible for fostering Chinese culture in Japan. The Japanese, as they have done so often in their history, went through a period of great enthusiasm for everything foreign, and Chinese art, Chinese learning, and Chinese ideas were all the rage during the Ashikaga period. Zen priests acted as artistic advisors to the shoguns and instructed the trading missions on which paintings, calligraphies, and ceramics to acquire for the Japanese court. Zen not only dictated the selection of art objects to be imported to Japan; it moulded the taste for art itself. Many of the leading painters, such as Noami, Shubun and Sesshu, were Zen priests, and the monasteries were often great artistic centers. Literature, especially poetry, was pervaded by Zen thinking, and the Noh theater reflects Zen teaching both in its aesthetic concepts (such as its artful simplicity, and its use of silence) and in various of the ideas expressed in the plays. Many elements of Japanese culture which today seem typically Japanese— flower arrangement, landscape gardening, the tea ceremony, *sumi-e* (ink painting), the cult of the subdued, the

love of simplicity and understatement—were all borrowed from Chinese Zen during the Ashikaga period. Over the centuries, however, they have become such an integral part of Japanese culture that they are no longer felt to be foreign or, for that matter, even particularly Zen.

In the Momoyama period (1573–1615), Buddhism began to decline in Japan, and during the Edo period (1615–1868), when the Tokugawa shoguns tended to favor Confucianism, most of the traditional sects lost much of their vitality. To a certain extent, Zen continued to hold its own, and a new Zen sect known as Obaku was introduced by the seventeenth-century Chinese monk Yin-yuan, who is better known by his Japanese name, Ingen. The doctrines of this sect are based upon the teachings of the ninth-century Ch'an master Huang Po, who is famous for his work on the doctrine of the Universal Mind (which has now been translated into English[17]) and, along with Hui-nêng's Sutra of Wei Lang, is one of the great classics of Zen literature. The center of this new sect was Mampuku-ji in Uji, not far from Kyoto, which was built in the Chinese style of the Ming period. But Obaku never proved as popular as the two older Zen sects, and today it has been merged with the Rinzai school.

Among the Zen masters of the Edo period, by far the most remarkable was Hakuin, who lived from 1685 to 1768. He was the great reformer of Zen Buddhism who revitalized the Rinzai sect and reconstituted the *koan* system. A vigorous and creative man, Hakuin was a great teacher as well as an outstanding painter, and he is credited with having trained no less than eighty successors in Zen doctrines. The present form of the *koan* system is largely the result of his work, and he organized the complete course of study of the Rinzai sect, which he divided into six stages, leading from the first step when the novice "enters into the frontier gate of Zen" to the "hard to penetrate" *koan,* and finally to the "study of Buddhist precepts and the regulations of the monks' life (vinaya) in the light of Zen understanding."[18] Normally this training takes about thirty years, but it is not necessary for every monk to complete the whole course in order to achieve

satori. Only those who are planning to become masters, or *roshi,* must finish the entire six stages so that they will be thoroughly versed in all the "skillful means."

Over the centuries, Zen in China became fused with Taoism and Confucianism, thus ceasing as a major cultural force, but in Japan it permeated the entire culture, entering every phase of Japanese life. An example of a form marked by Zen is the seventeen-syllable poem known as haiku. Its greatest practitioner was the early Edo poet Basho, who roamed the countryside as a wanderer like the Zen sages of old. Although few of his poems are religious in a strict sense, all of them are imbued with a Zen feeling toward the world. As Professor Harold Henderson says, among the qualities found in his work and often considered indicative of Zen are "a great zest for life, a feeling that nothing is alone, nothing unimportant, a wide sympathy; an acute awareness of relationship of all kinds, including that of one sense to another."[19] A good example of the directness and simplicity found in Basho and similar to that of Zen is the following poem.

> The Rose of Sharon
> By the roadside
> Was eaten by the horse.[20]

In recent years there has been a revival of Zen, which has even found serious students and followers in Western countries. Most notable among contemporary teachers is Daisetz Suzuki, who studied at the celebrated Zen monastery of Engaku-ji at Kamakura and after years of training experienced *satori*. He has been very active as a writer and teacher of Zen, not only in Japan but also in England and the United States. Now a man of ninety, he has written over one hundred books on Buddhism in general and Zen in particular, and he has become the most articulate spokesman for Zen to the people of the Western world. His most recent book, *Zen and Japanese Culture,* relates Zen to many different phases of Japanese life and shows how Zen attitudes and Zen ideals have influenced not only the religious and philosophical thinking of the Japanese, but even the life of the common people.

■ CHAPTER THREE

Chinese Painting
under Ch'an Inspiration

ALTHOUGH the T'ang period was the golden age of Ch'an Buddhism, there is little evidence that it exerted any marked influence on the arts. The T'ang Buddhist paintings which have survived would seem to indicate that the traditional Buddhist sects, especially the esoteric ones and those emphasizing the cult of Amitabha, dominated the scene. The earliest evidence of a painting which could be said to be related to Ch'an Buddhism is a pair of scrolls which are traditionally attributed to the tenth-century master Shih K'o but which at best are thirteenth-century copies of earlier originals. There can be no doubt that these two paintings reflect Ch'an influence, both in the subject (which shows two patriarchs, one of them leaning on a tiger, and the other seated in meditation) and in the style, which is characteristically Zen in its rough spontaneous manner, known as the *i-p'in* or untrammeled style. Instead of a conventional brush, the artist has used a brush of straw or shredded bamboo, thus achieving a strength and freedom which marks much of later Ch'an painting. Since literary descriptions of Shih K'o's work say that he used the *i-p'in* manner, this has been accepted as proof that these paintings are free copies of his work, but in light of the fact that no other examples of this type of painting from such an early date have come down to us, and that the style is typical for the painting of the

Southern Sung period, it seems more likely that they are thirteenth-century works which have no connection with Shih K'o.

Equally little is known about Ch'an painting during the Northern Sung period (960–1127), but we are told that several Ch'an monks associated with the circle of the great statesman and poet Su T'ung-po were amateur painters. Their works have not survived, but they were probably similar to the typical painting of the period. The only twelfth-century work which is definitely known to have been painted by a Ch'an priest, Fan-lung by name (and which is now in the Freer Gallery of Art in Washington, D.C.), does not show any characteristics which would distinguish it from other scrolls of the time. Even the subject, a series of Arhats, or Buddhist holy men, although sometimes associated with Ch'an, is by no means unique to this sect, and the style, though perhaps freer and more fluid than that of an academic work, is certainly no different from the literati painting of the period.

The evidence would suggest that a distinct school of Ch'an painting, differing from other schools both in choice of subject and in style, did not appear until the later part of the Southern Sung period, around the middle of the thirteenth century. Disappointingly little is known about the lives and careers of these painters, and almost none of their works exist in China, since Chinese art criticism has been dominated by the literati, or gentlemen-painters, who were very critical of the accomplishments of these masters. Fortunately the Japanese, who admired the Ch'an artists above all others, eagerly collected their work, so that today in Japan there are many outstanding examples of the Sung painting of this school which have been preserved with great reverence in Zen temples and in the private collections of old families.

The most celebrated of these works are in the Higashi-yama collection, which belonged to the Ashikaga shoguns and is named after the section of Kyoto where the Shogun Yoshimasa built his Silver Pavilion in the fifteenth century. At that time, special emissaries were sent to China to hunt for works by the great Ch'an painters of the

Sung period, and we are told that for the famous Mu-ch'i triptych of Kannon with the monkey and the crane, the shogun paid fifty times the price received by the best Kyoto court artist. The Chinese, who had lost interest in this type of painting, did not try to keep these works in China, and it is for this reason that the bulk of Chinese Ch'an painting is now in Japan.

The work of these artists represents a distinct break from traditional religious painting. While the older sects produced religious icons painted in a meticulous academic style and using conventional subjects such as Buddhas, Bodhisattvas, Paradise scenes, and mandalas, the Ch'an painters used a different style with subjects that reflected Ch'an teaching. If Sakyamuni was shown at all, he was seen, as in Liang K'ai's famous picture, as a hermit descending from the mountain after experiencing enlightenment and not as a god in Paradise surrounded by multitudes of heavenly beings as was the custom in traditional Buddhist art. Instead of Bodhisattvas, the Ch'an painters preferred Arhats (in Chinese Lohan), the disciples of Buddha who achieved merit through their austere and dedicated lives. The most popular figure was now Bodhidharma, the founder of Ch'an Buddhism, who is usually shown not as a serene, expressionless sage, but as a fierce-looking man whose exaggerated eyes with beetling bushy brows and penetrating stare give expression to his spiritual strength (Plate 2). Other famous Ch'an figures shown in these paintings are the sixth patriarch, Hui-nêng, who is tearing up the sutras in Liang K'ai's celebrated scroll (Plate 5), or Tung-shan, the founder of the Soto school of Zen, whom Ma Yuan showed achieving enlightenment while crossing the river and seeing his own reflection. Besides the historical figures, there are portraits of contemporary Ch'an masters, such as the picture of the painter Mu-ch'i's teacher, an abbot named Wu-chun. A favorite subject is Han-shan and Shih-tê (in Japanese, Kanzan and Jittoku), the one carrying a broom to sweep away the cobwebs in the mind and the other holding a blank piece of paper to show that the true doctrine is found not in the scriptures but in the heart (Plates 9 and 18).

Their carefree behavior and seemingly foolish laughter is characteristic of Zen. Most typical of all, perhaps, is Pu-tai, the pot-bellied Chinese incarnation of Maitreya, the Buddha of the Future, who wanders about happy in the knowledge that he has found the Buddha in himself (Plate 4).

What all these figures have in common is a radically different relationship to reality. To them, conventional Buddhism and accepted modes of behavior had become meaningless, and as a result, they seemed eccentric, roaring with laughter and acting like maniacs. A famous Zen story which Yin-t'o-lo used as a subject in a well-known Ch'an painting (Plate 8) is typical of their unexpected and sometimes even shocking way of acting. The story is as follows. Once when the Ch'an priest Tan-hsia (Tanka in Japanese) was staying at a monastery in the capital, he found the cold so severe that, unable to stand it any longer, he took a wooden Buddha image and made a fire of it to warm himself. At this, the keeper of the temple became very excited. "How dare you burn up my wooden Buddha?" he cried. Tan-hsia, completely undisturbed, began to poke the ashes with a stick. He said, "I am gathering the holy sariras (indestructible substance found in the bodies of saints when cremated) in the burnt ashes." "How could you get sariras by burning a wooden Buddha?" asked the keeper, to which Tan-hsia replied, "If there are no holy sariras to be found in it, may I have the remaining two Buddhas for my fire?"[21]

Finally, among the subjects used by Zen, there are the so-called cow-herding pictures which originated in China but became especially popular in Japan. The earliest were made in the Sung period by the Ch'an teacher Ch'ing-chü, and they were further developed by the monk K'uo-an. His series consists of ten pictures illustrating the stages of spiritual progress of the Ch'an student. First he is shown looking for the cow; next he discovers its traces; then he sees the animal itself. In the following pictures the cow is caught and herded, and then, the struggle over, the pupil is seen coming home on the cow's back. In the seventh and eighth pictures, the cow is forgotten, and

both beast and man disappear from sight. Finally, in the last picture, the pupil has returned to the source, back to the origin of all things. "Barechested and barefooted, he comes out into the market-place. Daubed with mud and ashes, how broadly he smiles! There is no need for the miraculous power of the gods, for he touches, and lo!, the dead trees come into full bloom."[22]

It was not just the new subject matter which set Ch'an painting apart from other Chinese schools; the style itself had its own distinct flavor. The wall paintings which had been customary in Buddhist temples were no longer used in temples of the Zen sect; and the large hanging scrolls, done in bright colors and intended for public display, were replaced by smaller pictures painted in monochrome and intended for individual devotion. The ink style used by the Ch'an painters was not, of course, their own invention, but they perfected it and carried it to its ultimate fulfillment. Chinese critics refer to this category as the *i-p'in* or "untrammeled" class of painting, a manner which had first been developed by certain eccentric artists of the T'ang dynasty. It is a free, spontaneous style which suited the spirit of Ch'an, with its emphasis upon sudden enlightenment. Just as the sage might see the truth in a flash, so the artist, seized by inspiration, could paint his picture in a matter of minutes. What counted was not hours of laboriously worked out detail, but brief periods of highly concentrated activity. The medium itself encouraged this approach, for in ink painting, especially in the *p'o mo* or spilled-ink type (which was a favorite with the Ch'an masters), nothing could be changed once the brush strokes had been put down. Such a method required both skilled technique and clarity of vision, for there could be no uncertainty, no hesitation, no redoing if the work was to have the inspired quality expressive of Zen. The subdued and yet forceful style of these ink paintings, with their strong contrasts of black and white, and their emphasis on tonal effects with the gradations of ink representing (as the famous critic Chang Yen-yüan said) five different colors, is already indicative of the Zen spirit. The background is always the white paper or empty

silk, whose blankness represents space. This too mirrors the Zen concept of life. As Eugen Herrigel says, "Space in Zen painting is forever unmoved and yet in motion, it seems to live and breathe, it is formless and empty and yet it is the source of all form, it is nameless and yet the reason why everything has a name. Because of it things have an absolute value, are all equally important and meaningful, exponents of the universal life that flows through them. This also explains the profound significance, in Zen painting, of leaving things out. What is not suggested, not said, is more important and expressive than what is said."[23] This economy of means, this reduction of things to their essence is the heart of Zen painting, for the artist is not concerned with the appearance which the senses perceive, but with the reality which lies beneath the surface. To the Zen devotee, all of nature—animals, trees, flowers, blades of grass, even inanimate things like rocks—reveals this ultimate reality. In this way, both the abstract form and the content of these pictures give expression to Zen in a way that words cannot do, for meanings which are beyond language become concrete in visual form.

The center of Ch'an painting was the monastery of Liu-t'ung-ssu located in the hills above the Western Lake near the Southern Sung capital of Hangchou. The founder of this monastery, and the finest of all these late Sung Ch'an artists, was the monk Fa-ch'ang, better known by his artist's name, Mu-ch'i. Little is certain about his life, but it is believed that he lived from about 1210 to 1280, so that his activity as an artist must have coincided with the last decades of the Sung dynasty. Few references to his work can be found in Chinese sources, and only one of his paintings (a rather minor hand scroll showing vegetables, flowers, and birds) is preserved in China today. The academic critics seem to have had little appreciation for the boldness and originality of his style, for they refer to him rather slightingly. In one passage it is said that he "played with ink in a rough and vulgar manner and did not follow the rules of the ancients." In another: "He expressed his ideas quite simply without ornamental elab-

oration. His way of painting was coarse and ugly, not in accordance with the ancient rules, not for refined enjoyment."[24] Were it not for the fact that Japanese Zen monks had collected his work, he would have been all but forgotten. In Japan he has always enjoyed a tremendous reputation, and no other Chinese painter is as well represented in the Japanese temple collections, nor did any other artist exert a greater influence on subsequent Japanese painting.

Mu-ch'i's most characteristically Ch'an work, and certainly one of his masterpieces, is his painting of persimmons in the collection of the Daitoku-ji in Kyoto. It is deceptively simple, showing nothing but six persimmons isolated against empty space (Frontispiece). Three quarters of the surface is blank; near the bottom, five fruits stand in an irregularly spaced row (the first two touching, the third separate, the fourth overlapping the fifth), while one fruit, somewhat smaller than the others, is placed in front of the rest. This simple composition is subtly varied not just in spacing but in the shapes of the persimmons: two rounded, two oval, two roughly squared, yet no one of them exactly like another. The ink tones are even more strikingly varied, from the deep black of the stems and the leaves and the middle fruit, to dark to medium gray to light gray. Two fruits are indicated by a circular stroke of the brush, while the others are painted in. There is no dish, no stand, no background, no suggestion of a given time or place. Every particular is eliminated, with the result that there is an absolute concentration on the fruit. They are what they are—six persimmons suspended in time and space; yet they, too, like all nature, participate in the ultimate essence. This work is not a still life in the Western sense of the word; it is a great religious painting of a peculiarly Zen type. Suzuki, in discussing a picture of a hibiscus in the Daitoku-ji collection, a work which is usually attributed to Mu-ch'i, has this to say about such paintings: "The secret is to become the plant itself. But how can a human being turn himself into a plant? In as much as he aspires to paint a plant or an animal, there must be in him something which corresponds to it in

one way or another. If so, he ought to be able to become the object he desires to paint. The discipline consists in studying the plant inwardly with his mind thoroughly purified of its subjective, self-centered contents. This means to keep the mind in unison with the 'Emptiness' or Suchness, whereby one who stands against the object ceases to be the one outside that object but transforms himself into the object itself. The identification enables the painter to feel the pulsation of one and the same life animating both him and the object. This is what is meant when it is said that the subject is lost in the object, and that when the painter begins his work it is not he but the object itself that is working and it is then that the brush, as well as his arm and his fingers, become obedient servants to the spirit of the object. The object makes its own picture. This spirit sees itself reflected in itself. This is also a case of self-identity."[25]

While the "Persimmons" is Ch'an in feeling but not in theme, other Mu-ch'i works represent specifically Zen subjects. The most impressive is probably the seated figure of a Ch'an monk (or, as some scholars believe, an Arhat) which is now in the Seikado, the museum established by the Iwasaki family on the outskirts of Tokyo. Though different in style from the "Persimmons"—less abstract and with a greater use of detail—it expresses the feeling of Ch'an Buddhism in a forceful and inspired way. The holy man is seated on a mountain terrace against trees and overhanging rocks, with a snake coiled around him, its gaping jaws in his lap. The monk, lost in spiritual concentration, is completely unperturbed. His strong face, with the blank yet piercing eyes, expresses the disciplined intensity of his meditation.

Another work with a Zen subject is a painting of Bodhidharma which is traditionally ascribed to Mu-ch'i, although it is doubtful if it is by his hand (Plate 2). Bodhidharma, seen close up from the side, is shown as a squat, ugly, impressive man with a bulbous nose and a massive forehead. The eye glares from the lowering brow; the chin and upper lip are bearded; and an earring dangles from the large ear. A companion piece representing Lao-

tzu is also attributed to Mu-ch'i, although this, too, is probably not authentic. However, the style of these pictures, with their coarse line and the crude yet powerful manner of treating the subject, are typical of Mu-ch'i and the Ch'an school and reflect the unconventional approach of these painters. It is also interesting that Lao-tzu, the great Taoist teacher, should be coupled with the founder of Ch'an Buddhism, indicating that to the Zen mind, these two philosophies were closely related.

Of all Mu-ch'i's works, the most famous is the triptych representing Kuan Yin, the Bodhisattva of Mercy and Compassion, with a crane on one side and a monkey and its young on the other (Plate 3), a painting which was first in the collection of the Ashikaga shogun Yoshimitsu and, since the fifteenth century, has been owned by the Zen temple of Daitoku-ji. The combination of these figures is very much in keeping with Ch'an ideas, for the crane and the monkey stand for the wild and unspoiled beauty of nature, an association already suggested by the famous passage in Kuo Hsi's *Essay on Landscape Painting,* in which he says that the virtuous man takes delight in landscapes, "that in a rustic retreat he may nourish his nature; that he may constantly meet in the country fishermen, woodcutters, and hermits, and see the soaring of the cranes, and hear the cry of the monkeys."[26] A similar reference to these animals is also made by the Zen master Dogen, who said that if he used the title and wore the robe conferred upon him by the retired emperor, he would be "laughed at by the monkeys and cranes among whom he lived as the old man in the purple robe."[27] That Mu-ch'i combines them with Kuan Yin, the Bodhisattva of Compassion, whom he shows seated among rocks, water, and trees, is typical of the Zen approach to the Buddhist deities, who are shown not as gods dwelling in paradise but as close to nature. As Suzuki says, "Zen brought God in Heaven down to earth. . . .Kannon (Kuan Yin), Goddess of Mercy, was not to be kept enshrined somewhere in a sanctified locality; Monju (Wenchu), the Bodhisattva of Wisdom, was not imprisoned up at the summit of Mount Wu-tai. Both Kannon and

Monju were brought down to market or the woods or anywhere we humans are accessible. Kannon was pictured with a basket filled with fish, Monju came out to our world accompanied by the monkey and the crane."[28]

The style of the triptych is characteristic of the best Chinese ink painting of the period, for it combines vigorous brushwork with subtle handling. Kuan Yin is shown as a gracious being, feminine in appearance, with a calm, detached expression. The motionless central figure, suspended in meditation, is balanced by the strong, striding movement of the crane, whose long legs, jutting neck, and opened beak embody a tense vigor. To the right are the monkeys, quieter in movement but forcefully portrayed, the small one held in the crooked arm of the large one, who is perched in the middle of an old tree. The long dark hairy limbs are curved in a rhythmic pattern which is echoed in the gnarled branches of the tree. Again, the brushwork is varied. In some places the strokes are broad, in others they are small and sharp, in still others they are sketchy and soft. Altogether, the triptych shows a painter who combines depths of spiritual feeling with great artistic mastery.

Like most of the celebrated painters of his time, Mu-ch'i also produced outstanding landscapes. Fragments of two scrolls, both of which represent the Eight Famous Views of the Hsiao and Hsiang Rivers, have been preserved in various private Japanese collections. The titles of these views, such as "Autumn Moon over Lake Tung-t'ing," "Evening Rain over Hsiao and Hsiang," and "Sunset over the Fishing Village," indicate their poetic mood. The theme is traditional—there are many scrolls of these famous sites—but Mu-ch'i does not try to show the places as they really exist. Instead, he suggests their appearance by a few elusive forms rendered in the most subtle and delicate ink washes. Again and again he paints vast and mysterious landscapes, with misty mountaintops, water, trees, and at times, almost overlooked against the grandeur of nature, the tiny figure of a fisherman in a boat, or a few small houses set among picturesque trees. The idea of these landscapes (which of course go back to

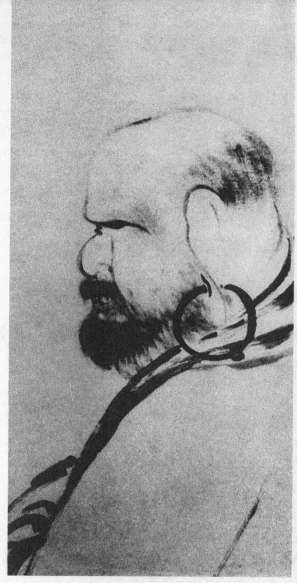

2. "Bodhidharma." Mu–ch'i. Private collection, Japan.

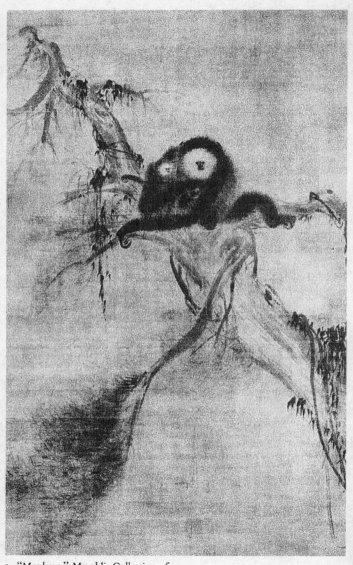

3. "Monkeys." Mu-ch'i. Collection of
the Daitoku-ji, Kyoto.

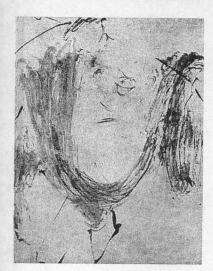

4. "Pu-tai." Liang K'ai. Murayama collection, Osaka.

5. "Patriarch Hui-nêng Tearing Up the Sutras." Liang K'ai. Mitsui Collection, Tokyo.

雨艷雲晴眺長沙
隱隱殘虹帶晚霞
最好市橋垂柳外
酒旗搖曳有人家
　山市晴嵐

6. "A Mountain Village in Clearing Mist." Yü-chien. Yoshikawa collection, Tokyo.

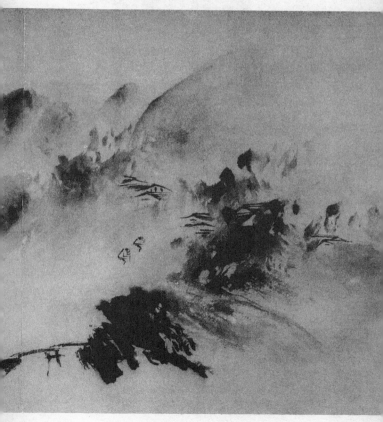

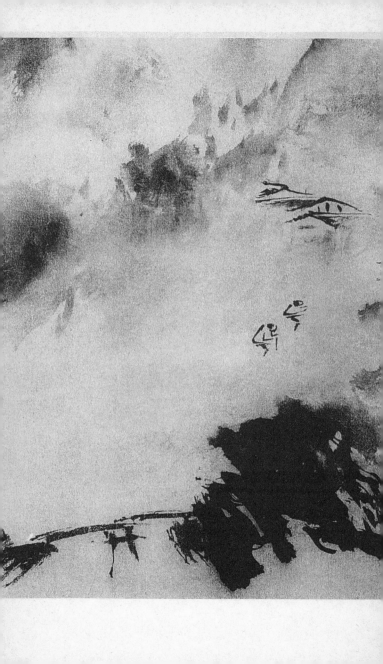

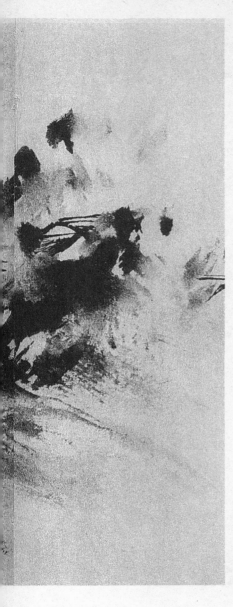

7. "A Mountain Village in
Clearing Mist" (detail).
Yü-chien. Yoshikawa
collection, Tokyo.

古寺天寒夜一宵不禁風泠雪霜～玖
無箇於何奇特且取堂中木佛燒

8. "Tan-hsia Burning the Buddha Statue."
Yin-t'o-lo. Private collection, Japan.

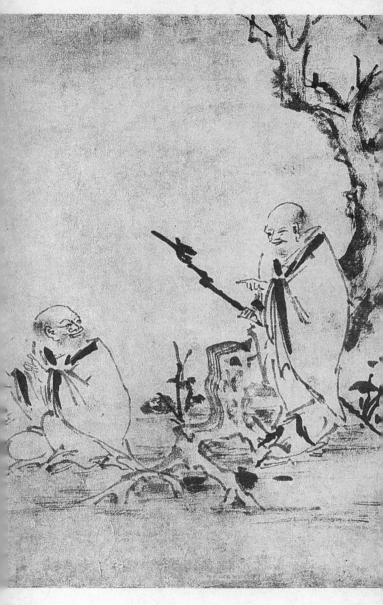

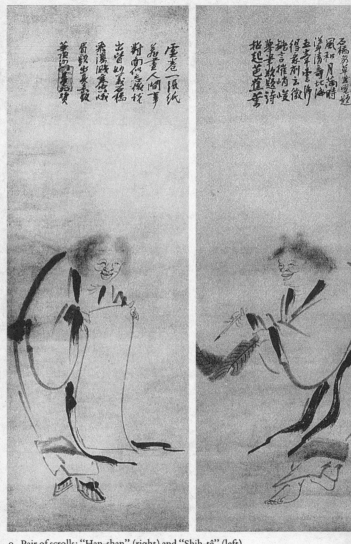

9. Pair of scrolls: "Han-shan" (right) and "Shih-tê" (left).
Yin-t'o-lo. Tokyo National Museum.

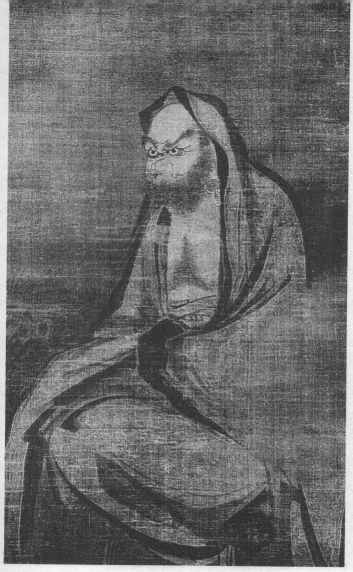

10. "Zen Monk in Meditation." Attributed to Yen-hui.
Museum of Fine Arts, Boston.

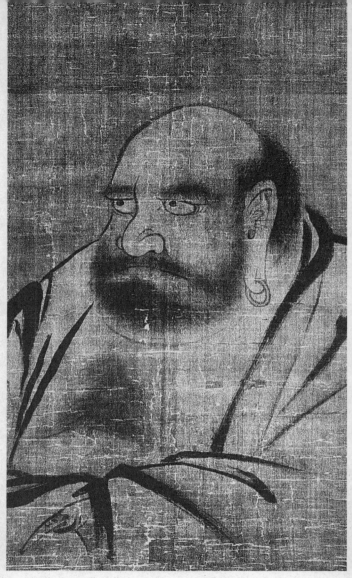

11. "Bodhidharma." Unknown artist. Freer Gallery of Art, Washington.

the nature mysticism of the Taoists) is that of the insigni-
ficance of man in relation to the cosmos, for it was only
by losing oneself in the vastness of nature that one was able
to find oneself, to discover what the Zen masters would
call one's own Buddha-nature. In this sense these land-
scapes, although not ostensibly Buddhist paintings, are
Ch'an in feeling, for as the *Zenrin Kushu,* a Zen anthology
of the sixteenth century, says, "The voice of the mountain
torrent is from one great tongue, the lines of the hills, are
they not the Pure Body of Buddha?"[29] In fact all of na-
ture—the rocks, the trees, even the grass—is Buddha.
"How good it is that the whole body of Kannon enters
in the wild grasses! . . . The old pine tree speaks divine
wisdom, the secret bird manifests eternal truth."[30] To the
Zen devotee, idols and icons were completely unnecessary,
a belief which Eicho, the compiler of the *Zenrin Kushu,*
expresses when he says that he can take a blade of grass
and use it as a sixteen-foot gold Buddha.

Somewhat older and originally an academic painter,
Liang K'ai was the second of the great Ch'an painters of
the thirteenth century. Only a few facts are known about
his life, among them that he received the Golden Girdle
(which he refused), and was made a member of the Im-
perial Academy at Hangchou. Apparently an unconven-
tional person, fond of wine, he called himself Liang, the
Crazy Vagabond. In middle life he renounced all official
honors and became a lay adherent of the Ch'an sect,
settling in the famous Liu-t'ung-ssu monastery which
had been founded by Mu-ch'i. A Chinese record says,
"He was a skilled artist good at a wide variety of subject
matters such as figures, landscapes, religious and legendary
subjects and others."[31] Although many works attributed
to him have been preserved, few appear to be authentic,
and most of these are in Japanese collections. Like Mu-
ch'i, Liang K'ai was very popular in Ashikaga Japan, and
several of his works are listed in the catalog of Chinese
paintings owned by the Ashikaga shoguns. The Zen
monks and the tea masters greatly admired his work, and
many copies of his paintings were made in Japan.

Liang K'ai's early style, while he was still a member of

the Imperial Academy, is best exemplified by the celebrated "Sakyamuni Descending from the Mountain of His Awakening," formerly in the Sakai collection. It is painted in a detached and meticulous manner characteristic of an older academic tradition, although the landscape setting suggests the freer and more spontaneous style of his mature period. What makes this work outstanding is the moving way the artist has rendered Sakyamuni's expression as he contemplates the tragic nature of life. A bleak setting reinforces the sense of melancholy. The vigorous and inspired brushwork in the figure, and especially in the rocks and branches and prickly bush, make certain that this scroll is an authentic Liang K'ai.

After he became a Ch'an follower, Liang K'ai's work changed drastically, and he often painted subjects which were based on Zen stories. Among these the most outstanding is a pair of hanging scrolls, one of which represents the sixth patriarch, Hui-nêng, cutting a bamboo, and the other showing Hui-nêng tearing up the sutras (Plate 5). The former, now in the Tokyo National Museum, is an original, while the latter, which is in a private Japanese collection, is today believed to be an accurate Japanese copy of a lost picture by Liang K'ai. Both are typically Ch'an in style as well as in subject and show the great influence that this sect exerted upon the artists of the time. The loose brushwork, depending almost entirely on forceful, jagged, rapidly drawn lines, is typical of the Zen belief that inspiration may come with the speed of lightning. The subject matter of the scrolls is also typical of Zen. In one, Hui-nêng, the great Chinese Ch'an master, is busy chopping bamboo, a simple task which recalls the fact that before he was chosen sixth patriarch, he did ordinary manual labor around the monastery. In the second scroll he is gleefully tearing up the sacred writings, showing that the true doctrine is written in the heart.

Among the numerous scrolls attributed to Liang K'ai, few are specifically Ch'an in inspiration, nor can many be assigned to him with certainty. Among those which can, the most interesting are two scrolls of Pu-tai (in Japanese,

Hotei), the Chinese incarnation of Maitreya, the Buddha of the Future. One, now in the Murayama collection, shows him carrying a bundle on a stick (Plate 4), while in the other (in the Sakai collection), he is watching a cockfight. Of the two, the former is the most characteristic of Zen, both in its style and in the philosophy it expresses. Liang K'ai concentrates not just on the figure—which appears close up, filling the entire picture—but on certain aspects of the figure, emphasizing those which he considers important and leaving the rest out. The broad face is dominated by the overlarge laughing mouth. Neck, shoulders, arms, and hands are left almost entirely to the imagination, so that the upper part of the body is reduced to a big globelike head grinning above an enormous belly. The U-shaped robe is dashed in so sketchily that it is difficult to tell how it hangs or even where it begins or ends. Two striding legs carry the laughing figure towards the onlooker—a figure which is the very incarnation of the Zen man who, having freed himself from the concerns of society, can lead a carefree and simple life. The other painting, which is not quite as good in quality, may also be an original, although the style is somewhat different, depending more on heavy, dark areas of ink than on the sketchy, lighter lines of the picture in the Murayama collection. However, the spirit of the work is much the same, showing Pu-tai living like a true Zen man for the experience of the moment.

Also attributed to Liang K'ai are two versions of another favorite Zen subject, the wise fools Han-shan and Shih-tê. In both works (the better one of which is now in the collection of the Hakone Museum), the two Zen figures are shown in a characteristic way, behaving like crazy children who roar with laughter, taking life as it comes, free from all conventions because they are secure in the knowledge that they have grasped the ultimate truth. Although the soft, rather weak brushwork of the Hakone picture is not as good as the best of Liang K'ai, it is very close to his manner and may well be an original.

Like Mu-ch'i, Liang K'ai also painted landscapes, of which two outstanding originals have been preserved.

These pictures, as well as many other scrolls attributed to the artist, such as bird and flower paintings, figures, and landscapes, cannot be considered particularly Zen either in style or inspiration. However, in view of the fact that Liang K'ai started as an academic painter and never officially joined the Ch'an sect, it is not surprising that much of his best work dealt with subjects drawn from the general pictorial repertoire of Chinese painting rather than being specifically Zen in nature. Of course the reverse is also true—purely secular painters who had no connection with Zen would at time treat typically Zen subjects.

The third of the great Ch'an painters of the thirteenth century was a Zen monk who is known by the name Yü-chien, or Jade Stream. There is some question about his exact identity, since two artists of that name, both of whom were Zen monks, lived during the late Southern Sung period, but judging from the accounts of his life and work which appear in Chinese literature, it would seem that the artist who painted the wonderful pictures now preserved in Japan must have been the monk Jo-fen, who called himself Yü-chien after a pavilion located at the mountain stream where he had retired. His most celebrated work, which belonged to the collection of the Ashikaga shoguns and which at that time was already looked upon as the best Chinese landscape painting of its type, is a scroll of the Eight Famous Views of Hsiao and Hsiang. Since the shogun wanted to see these marvelous pictures all at the same time, the scroll was cut up into sections during the Ashikaga period. Only three of the parts have survived, yet there can be no doubt that even in this fragmentary form, these works are among the greatest Chinese landscape paintings in existence. Of the three which remain, the finest (now in the Yoshikawa collection) is the one called "A Mountain Village in Clearing Mist" (Plates 6 and 7). Painted in the spilled-ink style, it embodies the very essence of Ch'an painting. The forms are extremely abstract, especially the mountains and the trees. The dark areas of the wooded slopes are splashed on in irregularly shaped blots, next to dabs and

streaks of lighter tones which are as fluid as water color. The people, the bridge, and the houses, are done in a kind of shorthand, almost like calligraphy, where a few swiftly executed strokes suggest a building, a roof, or a person toiling up the mountain. Many artists, such as the fifteenth-century master Sesshu, or the sixteenth-century Japanese painter who made a copy of this picture, have imitated but have not equaled the peculiar genius of this style. Superb formal mastery, the result of years of technical training, is combined with inspiration of the highest order. The result is a work which is at once spontaneous and controlled—in which, with a few strokes of the brush, the heart of the matter is seized. In our own period, various artists have tried to achieve similar effects. Men like John Marin have obviously been deeply influenced by such painting, but their work lacks the spiritual depth which makes this Yü-chien so unique. Even the other two sections from the same scroll are disappointing when compared to "A Mountain Village in Clearing Mist." One view, called "Harvest Moon over Tung-t'ing Lake," is now in the National Museum in Tokyo, while the other, "Fishing Boats Returning to the Bay," is in the collection of the Tokugawa Museum in Nagoya. In both there is the same subtle and suggestive brushwork and the same feeling of misty atmosphere and mysterious space, but they lack the strength and expressive power of the Yoshikawa section. Besides these pictures, there are fragments of another landscape scroll which are traditionally attributed to Yü-chien. Some Japanese scholars still assign both sets to the same artist, but since the styles are very different, it is possible that the fragments from the second set are the work of the other monk by the same name. Whoever the artist was, the paintings are certainly closely related to Zen Buddhism both in feeling and in style. The best of these fragments is the "Waterfall at Lu-shan in Mist," which is now in the Yoshikawa collection. Painted in an abbreviated style, the forms have become so vague that they seem almost to dissolve in the mist.

Somewhat later than Mu-ch'i, Liang K'ai, and Yü-

chien is the Ch'an painter known as Indra, or Yin-t'o-lo. Unlike the other masters of Zen painting, he was not a native of China but came originally from Magada in India. Although not even mentioned in Chinese literature, he must have enjoyed a considerable reputation both as a Buddhist master and as an artist, for several of his works were brought to Japan, where they have been preserved to this day. The exact dates of his life are not known, but it is believed that he was active during the second half of the thirteenth century—that is, at the very end of the Southern Sung period and during the early years of the Yüan. Of all the pictures discussed, those of Yin-t'o-lo are the most specifically Ch'an in character, reflecting in both their subject and style the teachings of this school. The most outstanding, a large scroll representing various Zen stories, has been cut into separate parts which are scattered over several Japanese collections. The scenes shown are such celebrated episodes as that of the priest Tan-hsia burning the Buddha statue (Plate 8), the patriarch Yao-shan engaged in a Zen dialogue with his disciple Li Ao, and the crazy fellows Han-shan and Shih-tê. This latter subject seems to have been a favorite with Yin-t'o-lo, for several versions have been attributed to him, the finest of which is the pair of hanging scrolls in the collection of the National Museum in Tokyo (Plate 9). Like the picture of Tan-hsia burning the Buddha, these scrolls are painted in a skillful, rather charming manner. Thick black strokes are used with light, gracefully curved lines to delineate the smiling, good-humored figures. In other versions Yin-t'o-lo shows Han-shan and Shih-tê in the company of the monk Fêng-kan and his tiger, forming a group of carefree figures, foolish and yet wise because they have discovered their Buddha-nature. Other pictures show such Zen favorites as Pu-tai, Bodhidharma, and Vimalakirti. All of these paintings are executed in a free-ink style characteristic of Zen, but they are decidedly inferior in quality when compared to the work of the great Ch'an painters of the Sung period. What makes them interesting from a Ch'an point of view is that, in addition to their Zen subjects, most of them

have inscriptions in the form of poems by Zen priests which suggest how closely they were related to the ideals of the sect.

In the fourteenth century, Ch'an Buddhism and the art which it inspired underwent a drastic decline. The leading masters of the Yuan period, such as Ni Tsan, Huang Kung-wang, and Wang Meng, were interested in the formal qualities of painting rather than the expression of religious or philosophical ideas. On a popular level Ch'an painting continued to be produced, although of an inferior quality, lacking the boldness and inspiration which much of the earlier work had possessed. Characteristic paintings of this later type may be found in both Japanese and American collections. For example, the Boston Museum has a scroll, traditionally attributed to the fourteenth-century Yen Hui, which shows a Ch'an monk in meditation (Plate 10), and the Freer Gallery has a likeness of Bodhidharma by an unknown painter of the Ming period (Plate 11). The fierce spiritual concentration of these figures, whose exaggerated eyes glare from beneath bristling eyebrows, is a reflection of their peculiar Ch'an character, even if the brushwork is coarse and obvious compared to that of the great masters of the thirteenth century.

During the early years of the Manchu dynasty, a group of eccentric painters was active, some of whom were either Ch'an monks or close to Ch'an Buddhism. Several of them, especially Shih-t'ao and Pa-ta Shan-jên, were artists with an individual and expressive style which has appealed to modern taste. However, despite the fact that their ink style resembles that of Ch'an painters, it would not be correct to class them with the Ch'an artists of the Southern Sung period. For one thing, they withdrew from the world for political reasons, and for another, their work is far closer to the tradition of literati painting which had existed in China for several centuries before Ch'an art became important.

■ CHAPTER FOUR

Zen Painting in Japan

CH'AN PAINTING began to flourish in Japan at the very time that it had virtually disappeared in China. With the coming of the Ashikaga shogunate in 1333, and the return of the seat of government to Kyoto, the traditional capital, ink painting became the great fashion, and the Japanese artists began working in the style of the masters of Sung China. It was during this period, notably the fourteenth and fifteenth centuries, that the wonderful collections of Chinese paintings were formed in Japan.

The Zen monasteries, which were sanctuaries of peace in these troubled times, were the center of this artistic activity. Many of the most famous painters were actually Zen monks, and almost all of them were deeply influenced by Zen, whose impact on Japanese culture was so profound that even the court artists could not help reflecting the prevailing taste. Not only were Zen subjects treated by practically every painter, but Zen itself had a far more lasting effect in Japan than it ever had in the country of its birth. While in China Ch'an Buddhism had been a special cult without any broad popular appeal, in Japan it permeated all of life, influencing not just art but ordinary things of everyday life.

The earliest of the Japanese Zen monk painters were Mokuan and Kao. Little is known about either, and few of their works have survived. Mokuan is believed to have

lived during the first half of the fourteenth century. In 1326 he is said to have traveled to China, where he remained for many years, studying Zen and perfecting himself in the art of ink painting until his death around 1348. Apparently much admired, Mokuan was celebrated as a reincarnation of Mu-ch'i, whose style he followed. This led to a confusion between their works, and it is now thought that many of the paintings traditionally attributed to Mu-ch'i are actually by Mokuan. The subjects he treated were usually taken from Zen legend, illustrating the lives of Zen saints, or dealing with enlightenment—a kind of painting which the Japanese call *doshaku-ga*. Most of his works have long inscriptions by contemporary Chinese Ch'an masters, suggesting the close association between art and religion in this type of painting. Among the surviving works of Mokuan, the finest is the scroll in the Maeda collection called "The Four Sleepers," showing the beloved pair Han-shan and Shih-tê (Kanzan and Jittoku in Japanese), with Fêng-kan (Bukan in Japanese) and his tiger (Plate 12). Painted in a loose, easy style, the figures are presented with a good deal of humor, lolling against each other and draped over the tiger, who looks as harmless as an overgrown cat. Although Mokuan was a follower of Mu-ch'i, this work also resembles that of Yin-t'o-lo in its light skillful line and its lack of any deep inner tension. There is nothing in the style or iconography that is specifically Japanese, and there can be no doubt that Mokuan saw his painting as a continuation of that of his great Chinese predecessors. Other works attributed to Mokuan are the painting of Hotei (Chinese Pu-tai), the fat, jolly incarnation of Maitreya, and a picture of a kingfisher—the one in the Sumitomo and the other in the Ohara collection. Although the theme of the latter does not seem particularly Ch'an, Zen artists often chose such subjects as an expression of the belief that the Buddha nature inhabits all living things.

Almost nothing is known about Kao, who was a contemporary of Mokuan's and is believed to have died in 1345. He too was a Zen priest, and devoted himself largely to Zen subjects. Judging from the few surviving works

attributed to him, his favorite theme was the two crazy friends, Kanzan and Jittoku. Three versions of Kanzan have come down to us, one in the Nagao collection, one in the Ueno collection, and the third in the Freer Gallery in Washington (Plate 13). To Zen Buddhists, Kanzan represented the ideal man who had overcome the world with its vanities and desires. We are told that he often "visited the Kuo-ch'ing monastery at T'ien-tai, where he was fed with whatever remnants there were from the monks' table. He would walk quietly up and down through the corridors, occasionally talking aloud to himself or to the air. When he was driven out he would clap his hands and, laughing loudly, leave the monastery."[32] Kao's versions of Kanzan, painted in the *suiboku* or water-and-ink style, are close to Liang K'ai in their simplicity and boldness although, like the work of Mokuan, they lack the dynamic force of the Chinese masters. The heavier line, the flat area of dark ink, and the shallow space give the Washington scroll a more distinctly Japanese quality, although it is still basically Chinese in style.

Also attributed to Kao are several other works, such as a portrait of the Zen master Hsien-tzu, a picture of Bukan, or Fêng-kan, and a painting of Sakyamuni as an ascetic, but their authorship is uncertain—in fact, the whole question of the identity of Kao is very obscure. Suffice it to say that during the last years of the Kamakura and the first years of the Ashikaga period, Chinese-style *suiboku* painting representing Zen subjects was already well established in Japan, and that some of these early *sumi-e* painters were accomplished masters.

The other type of Buddhist painting which flourished under Zen influence in Ashikaga Japan was portraits of Zen masters, a type of art known as *chinso*. These pictures were made either in commemoration of Zen priests for the temple in which they had served, or as presents to be given to the master's pupils as a sign that they had achieved enlightenment. The portraits, which frequently have inscriptions by one or more priests, are valuable historically as documents, as well as being of interest as works of art. Some of these likenesses are portraits of real penetration,

revealing the spiritual depth and power of the Zen leaders. Particularly moving is the painting of the great master Muso Kokushi by the Zen priest Muto Shui, dated 1349 and owned by the Myochi-in in Kyoto. Another version of Muso Kokushi, also by Muto Shui, is in the Obai-in at Kamakura (Plate 14). Though following the style of the Chinese portraits of the Sung and Yüan periods, the simple beauty of its line and the austere, calm, spiritualized expression surpass anything found among the Chinese portraits of the same period.

Perhaps the most famous of these pictures is the likeness of Shoichi Kokushi, the founder of Tofuku-ji, which is attributed to the monk painter Mincho (1352–1431), better known as Cho Densu, since he occupied the position of *densu* or caretaker of the buildings at Tofuku-ji (Plate 15). In its detailed realism, this painting is closer to the Chinese portraits of the time, depicting with great care not only the priest's appearance, with his blind eyes, his wrinkles, and his sagging, puffy throat, but also the details of his dress, from the slippers on the footstool, to the pattern of his robe, to the insignia of his rank as a Buddhist abbot. The contrast between the rich trappings and the worn, tired face of the old man gives the portrait a feeling of human depth. More informal and in a way closer to the Zen ideal of artistic creation is the ink sketch, also at Tofuku-ji, which represents the same abbot seated in a landscape. Painted in a free *suiboku* manner, it shows the priest, who was celebrated for his learning and his sense of humor, as he actually looked with his bald head and his bad eye. Another famous early Zen portrait is that of Daito Kokushi (the first abbot of Daitoku-ji), which was painted in 1334 by an unknown artist in a very meticulous manner and had a eulogy written on it by the Emperor Go-Daigo. This combination of calligraphy and portraiture is also seen in the deeply moving likeness of the great Zen teacher Ikkyu (1394–1481) by Bokusai, a priest at Daitoku-ji, which shows the writing of the master above his picture (Plate 16). Painting in the late fifteenth century, Bokusai has created a portrait very different from the Chinese-style portraits of his predecessors,

both in its directness and simplicity and in the emphasis upon the personality of the priest rather than the insignia of his rank.

The Japanese school of Zen painting which had originated during the fourteenth century reached its culmination during the fifteenth at a time when Ch'an art had all but died out on the continent. Besides portraits and paintings of Zen scenes, many landscapes were produced—in fact, by far the most common subject was the landscape. The views represented were always ideal Chinese landscapes with misty mountain peaks, gnarled pines, rocks, waterfalls, lakes or rivers—never the softer, more gentle landscapes of Japan. It might seem odd that Zen priests painted landscapes, but to them they were just as much a religious subject as the paradise scenes had been for the Buddhist artist of an earlier age. Although the underlying conception of the tiny sage contemplating the vastness of the cosmos, or the fisherman living in harmony with nature, is no doubt Taoist in origin, the idea was taken over by the Zen Buddhists, who were very close in philosophy to the Taoists. Like the Southern Sung painters, the Japanese expressed through the landscape their own mystic view of the world.

Of the painters of the early years of the fifteenth century, the two most famous were Josetsu and Shubun, who are reputed to have been the teachers of Sesshu. Both were priests associated with the great Zen temple of Kyoto, the Shokoku-ji, which served as a cultural center for the court. Little is known about Josetsu, and only a few works can be attributed to him with any certainty. The most famous is a typical Zen picture entitled "Catching a Catfish with a Gourd," which is owned by the Taizo-in of Myoshin-ji in Kyoto (Plate 17). Painted in the early years of the fifteenth century, with inscriptions by Taigaku Shusu and no less than thirty poems of other Zen priests, it is the earliest authenticated Japanese landscape in the Chinese style. Jagged mountaintops rise above mist in the background, and in the foreground there are bamboos, rushes, and a stream swirling around rocks. In the middle, standing at the edge of the bank, is a rustic who

is trying to catch the slippery catfish with a gourd. The scene is a Zen parable, the point being that it is just as hard to define the elusive nature of Zen as it is to catch a fish in a crude container. In this early example of the "new style" of Zen painting, as this scroll was called in its inscription, the landscape is combined with a Zen story, but there is no doubt that Josetsu and others were already painting pure landscapes in the Chinese style.

The priest Shubun, who is believed to have been a pupil of Josetsu, was active during the first half of the fifteenth century. Practically nothing is known about his life, aside from a few facts such as that he went to Korea in 1413 and that he made a Buddhist statue for Shi-tenno-ji in Osaka in 1443. His fame as an artist was so great that he was appointed to the position of chief government artist of the Ashikaga shogunate. Many works have been attributed to him, almost all of them landscapes, but few if any are accepted as authentic today. However, they must certainly reflect his style, and there is no doubt that they indicate the kind of poetic Chinese landscape which was popular among these Zen painters. The best is one entitled "Reading in a Hermitage in a Bamboo Grove," now in the National Museum in Tokyo, which can be attributed to Shubun with certainty because of the excellent brushwork and the lengthy inscriptions by Zen priests of the period. The theme of the hermit studying in a retreat among gnarled pines and mountains is typical of this kind of Taoist or Zen painting. The brushwork is delicate yet firm, employing heavy blacks and subtle grays and using the paper itself to give the illusion of space receding into a boundless depth. This type of picture is based upon Southern Sung masters like Hsia Kuei and Ma Yuan, who treated the same subjects and used the same type of composition and style.

Of the religious paintings traditionally attributed to Shubun, the most interesting from a Zen point of view (although probably not an original) is the picture of Kanzan and Jittoku formerly in the Tsugaru collection in Tokyo (Plate 18). Painted in a bold, expressive style, it displays vivid contrasts of tone, with strong blacks set-

ting off the white faces and Kanzan's white neck. Compared to the Kanzan by Kao, these figures seem wilder and more exuberant, with their big heads, their messy hair, and their wide-open, laughing mouths.

The most famous of the monk artists, and in the eyes of many critics the greatest Japanese painter, was Sesshu, who lived from 1420 to 1506. A pupil of Shubun, Sesshu lived as a young man at the celebrated Zen temple of Shokoku-ji. In 1467 he went to China, where he studied at such famed Buddhist centers as the monasteries on Mount T'ien-t'ung. There he spent several months and was honored by being given the first seat in the meditation hall, the seat of honor next to the abbot. That he valued this distinction is evident from the fact that he used the honorary title, "Occupant of the First Seat at T'ien-t'ung," on various of his paintings. His official mission was to purchase Chinese paintings for the Japanese rulers. Since his interest was largely in Sung work, Sesshu was very disappointed in the more realistic Ming paintings, and it was the landscape of China rather than the contemporary art which inspired him. After two years he returned to his own country, where he was greatly honored, and settled in Yamaguchi in western Japan.

Among the many works attributed to Sesshu, the most famous representing a specifically Zen subject is his painting of Daruma, the patron saint and founder of Dhyani Buddhism, which is owned by Sainen-ji in Aiichi Prefecture (Plate 19). It treats one of the most dramatic episodes in the history of Zen, namely Hui-k'o offering his arm to Daruma—the arm which he has just cut off with a sword as a sign of his determination to become a disciple of Daruma. Sesshu's treatment of this scene is not dramatic from a Western point of view. There are no shrieks, no spurts of blood, no violent reactions such as a Caravaggio might have painted. In fact, to any onlooker who is not familiar with the story, there is little in the figures to suggest the extraordinary event—Daruma is deep in meditation, while Hui-k'o, or Eka as he is called in Japan, stands quietly at his back. What is important is not the bloody act but the intense, almost fierce spiritual

power of the saint. The center of the picture is not Eka but the simple yet grand figure of the saint, with his exaggerated eyes and fierce expression. The treatment of the cave with its jagged rocks and the holes like eyes staring at the scene, carries out the mood with its tense lines and expressive contrasts of light and dark tones. In this work, which was done by the artist in his seventy-seventh year, Sesshu reveals himself as a great painter and a true disciple of Zen.

Several other pictures of Daruma are traditionally assigned to Sesshu, but none has the power of the Sainen-ji painting, and few would be generally accepted today as authentic works, although they may well reflect paintings of Sesshu which no longer exist. Among these, the best are those of Daruma and Eka standing waist-deep in the snow, a work in the Shimojo collection, and a bust of Daruma in the Ogura collection. The first illustrates another episode from the encounter between Daruma and Eka, who was the second patriarch of the Ch'an sect. Although it is a fine picture with vigorous brushwork, it cannot be compared to the far more impressive painting of Eka offering his arm to Daruma. The other picture, done in 1502 when Sesshu was eighty-three years old, shows the artist at the height of his power. Daruma is portrayed as a fierce figure with a bushy beard and large intense eyes mirroring the spiritual authority which he possessed. The strong, bold brushwork seems to give expression to the explosive character of Zen teaching. Among the many pictures of Daruma—a favorite subject of Zen artists both in China and Japan—none have quite the vigor that characterizes Sesshu's portraits of the great saint.

Like most of the outstanding Japanese artists of the period, Sesshu was primarily a landscape painter, and it is for his work in this genre that he is most celebrated today. One of his masterpieces is the Mori scroll, which is over fifty feet long and presents the landscape in the four seasons. A powerful work, it is one of the most remarkable of Japanese *sumi-e* scrolls, and many critics would rank it as the single greatest Japanese painting. Equally great

and more specifically Zen in spirit is the landscape of his old age which is now in the collection of the National Museum in Tokyo (Plate 20). Done in the *p'o-mo* or splashed-ink style, this work embodies the very essence of the Zen approach towards artistic inspiration, for just as *satori* comes in a lightning flash, so a work of art must spring from the depths of the unconscious. That this scroll was conceived as a revelation of the Zen attitude towards reality is indicated by the fact that it was painted for Sesshu's favorite pupil (who was not only a Zen monk but the librarian of a famous Zen temple), and that it has eulogies written by six Kyoto priests. One of these, an inscription by Keijo Shurin, says, "The Ancients spoke of painting in the same terms as Zen. It is not transmitted through books but directly by the heart. On a bit of paper, create darks and lights—mountains amid faint rain, (and you have) an inspired ink painting of the setting sun."[33] The style of Sesshu's landscape, called *haboku* in Japanese, is similar to that used by Yü-chien, who was greatly admired in Ashikaga Japan. The brush strokes range from deep rich blacks to the lightest grays, and the forms are abbreviated like modern expressionist painting, for Sesshu is not interested in a realistic copy of nature but in an instantaneous and intuitive rendition seized—as Keijo Shurin says—directly by the heart.

Among the painters who followed Sesshu, there were many who were either Zen priests or students of Zen and whose works reflect the spirit of its doctrine. This tendency is clearly evident in the work of Shokei, a Zen monk of Kencho-ji at Kamakura who held the office of *shoki,* a kind of secretary, and is therefore known as Kei Shoki. His dates are uncertain, but it is believed that he was active during the late fifteenth and the early sixteenth century and that he studied under Geiami, one of the foremost court painters of the time. Kei Shoki produced both landscapes and figure paintings, among them a picture of Daruma, now in the Zen temple Nanzen-ji, whose brushwork is forceful and terse and whose whole effect is very powerful.

Deeply influenced by Zen was Dasoku (or Jasoku), a

lay follower of the Zen master Ikkyu, whose portrait he painted. A member of the samurai class, he lived in Kyoto during the second half of the fifteenth century. He too painted both figures and landscapes, among which his Daruma triptych is the most important (Plate 22). In keeping with Zen ideas, it does not show Buddhas and Bodhisattvas in the Western Paradise—divine beings in a divine abode—but historical figures who were venerated as great teachers: Bodhidharma in the center; to his right the ninth-century patriarch Lin-chi, the founder of the Rinzai sect; and to his left, another great ninth-century teacher, Tê-shan (Tokusan in Japanese). Daruma is shown in the conventional way, bearded and scowling, with exaggerated, glaring eyes. His monumental three-quarter length figure, enveloped in a robe which covers both his hands and his head, overshadows the flanking figures, who are shown full length, clad in kimono and kneeling on the floor. Their heads, less generalized and painted with a lighter and more delicate line, lack the force of the Daruma image, which remains surprisingly strong even though it has been reduced to a convention. Other well-known works by Dasoku are "Sakyamuni as an Ascetic" and the sliding screens with landscapes and bird-and-flower designs which he painted for Shinju-an, the Zen monastery of which Ikkyu was the head priest.

By the end of the Ashikaga period, Zen-inspired *sumi-e* had become less prominent as other schools rose in importance. This decline was even more pronounced during the Momoyama and Edo periods, when the artistic scene was dominated by the official Kano school, the literary men's *nanga*, the popular ukiyo-e, the realistic Okyo school, and the decorative Sotatsu-Korin style. Yet Zen ideas and Zen subjects persisted, even among the academic painters of the Kano school, although their detailed, rather dry manner was hardly in keeping with Zen ideals. For example, the founder of the Kano school, Kano Masanobu (1434–1530), who is said to have been highly regarded by contemporary Zen priests, painted a traditional version of Hotei as a grinning, slovenly, pot-bellied figure whose carefree expression indicates that he has found

peace in Zen. Masanobu's son was Kano Motonobu (1476–1559), under whom the Kano school became established as the official school of the shogunate, a position it held throughout the Tokugawa period (1615–1868). An eclectic artist, he worked in a great many styles, following both Chinese and Japanese models, but it is interesting to note that his most outstanding works are the panels he did for the Reiunin hall of Myoshin-ji, where his friend and teacher, the Zen priest Daikyu, lived. Also specifically Zen are his pair of hanging scrolls (now in the National Museum of Tokyo but originally painted as sliding screens for the Daisen-in in Kyoto) which represent the *satori* experience of two famous Ch'an masters, Lung-yün (in Japanese, Rei-un) and Hsiang-yen (in Japanese, Kyogen). One master experiences enlightenment while viewing the peach blossoms at the foot of a waterfall; the other has his revelation while sweeping the ground beneath the bamboos in front of his hermit's hut. Although the style of these pictures is not Zen, the idea that *satori* may come in the midst of the most uninspiring sort of task touches the very core of Zen thinking.

Among the artists of the early Edo period, the one most deeply imbued with Zen is Miyamoto Musashi, who lived from 1584 to 1645. Known primarily as a swordsman, he was also an outstanding painter who worked under the name of Niten. The directness, boldness, and decisiveness necessary for good swordsmanship is also evident in his painting, which is typically Zen both in spirit and style. Unlike the Kano-school painters, he does not emphasize detail but creates freely and swiftly with a few strokes of the brush. One of his strongest paintings is a bold and expressive likeness of Daruma. Another painting usually attributed to Niten shows Daruma crossing the Yangtze on a reed, but this work does not have the strength of the other picture. Also marvelous are his inspired paintings of birds, such as the celebrated cormorant in the Hosokawa collection (Plate 21), and the shrike in the Nagao Museum. Aldous Huxley, in commenting upon the latter work, says, "The effects of isolation combined with proximity may be studied, in all their magical

strangeness, in an extraordinary painting by a seventeenth-century Japanese artist, who was also a famous swordsman and a student of Zen. It represents a butcher bird perched on the very tip of a naked branch, 'waiting without purpose, but in a state of highest tension.' Beneath, above and all around is nothing, the bird emerges from the Void, from that eternal namelessness and formlessness, which is yet the very substance of the manifold, concrete and transient universe. That shrike on its bare branch is first cousin to Hardy's wintry thrush. But whereas the thrush insists on teaching us some kind of lesson, the Far Eastern butcherbird is content simply to exist, to be intensely and absolutely there."[34]

The outstanding Zen painter of the middle Edo period —that is, the eighteenth century—was the Zen master Hakuin (1685–1768). An influential teacher and a prolific writer, Hakuin is credited with reinvigorating the Rinzai sect by translating the often difficult and obscure terms of traditional Zen philosophy into colloquial Japanese. Although not a professional artist, he produced works of striking originality. Until recently, the kind of painting he practiced has been neglected by art historians and critics. Known as *Zenga,* or Zen painting, it is inspired amateur work of a special kind, filled with spiritual force, refreshing naïveté, and delightful humor.

Hakuin's favorite subjects were portraits of great Zen masters and themes from Buddhist lore. Shaka as an ascetic, Kannon Bosatsu, Vimalakirti, and Fudo Myo-o are among the figures he painted, but his most wonderful works are those which represent Daruma. Several versions exist, one of the most interesting in the Hosokawa collection (Plate 23). The traditional image of the massive, scowling, fierce-looking Daruma is almost completely changed—there is a long, lopsided head; a wizened face with a large nose and small chin; and, strangest of all, huge eyes, one bigger than the other, with small, upturned centers staring from exaggerated areas of white. The brushwork is coarse, with thick gray strokes painted over thinner lines that sketch the figure almost as though with a pencil. Strong black strokes mark

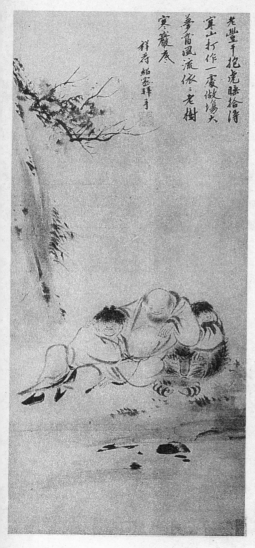

豐干抱虎睡拾得

寒山打作一團做場大

夢當風流依々老樹

寒巖底

祥寺紹密拜寺

12. "The Four Sleep-
ers." Mokuan. Maeda
collection, Tokyo.

13. "Kanzan." Kao. Freer Gallery of Art, Washington.

14. "Muso Kokushi."
Muto Shui. Collection
of the Obai-in, Kama-
kura.

15. "Shoichi Kokushi." Cho Densu. Collection of the Tofuku-ji, Kyoto.

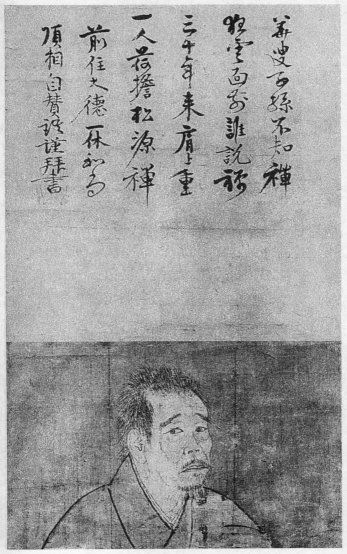

崢嶸面孔誰説禅

三十年来肩上重

一人荷擔松源禅

前住大徳一休宗純

頂相自賛謹拝書

筆捜子孫不知禅

16. "Ikkyu." Bokusai. Tokyo National Museum.

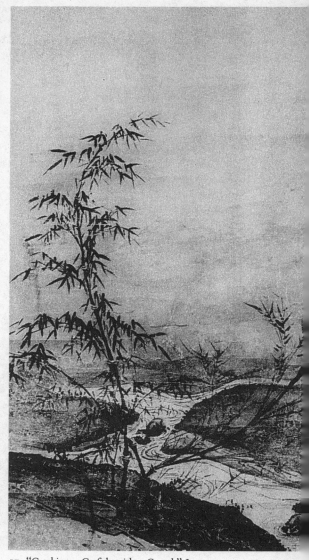

17. "Catching a Catfish with a Gourd." Josetsu.
Collection of the Myoshin-ji, Kyoto.

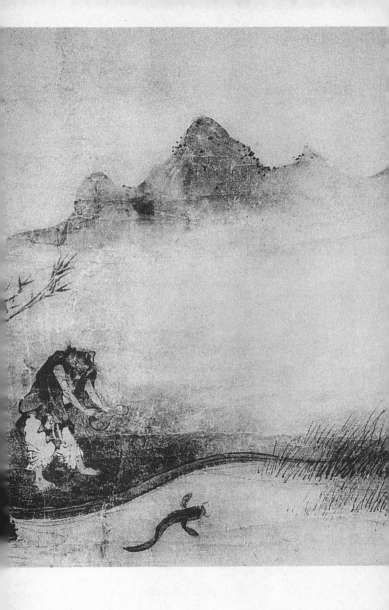

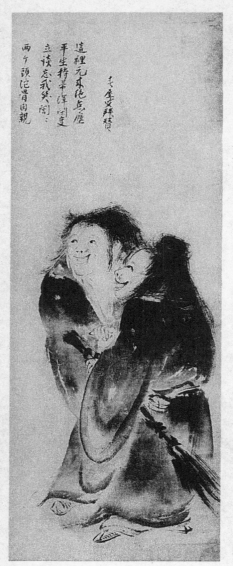

這裡元來他点塵
平生拄箇〔…〕〔…〕〔…〕
立読志我笑〔…〕
雨ケ頭〔…〕〔…〕同親

18. "Kanzan and Jittoku."
Shubun. Tsugaru collection,
Tokyo.

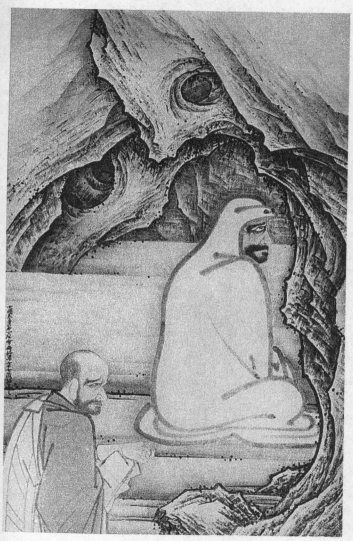

19. "Hui-k'o Offering His Arm to Bodhidharma." Sesshu.
Collection of the Sainen-ji, Aichi Prefecture.

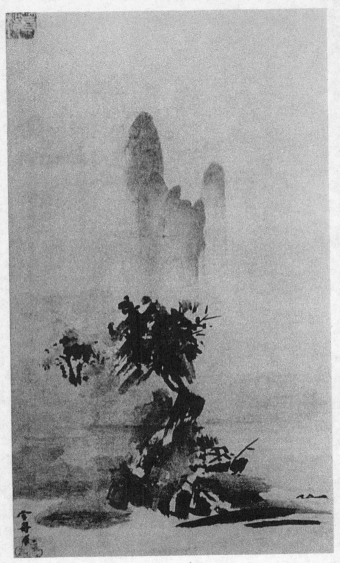

20. "Landscape." Sesshu. Tokyo National Museum.

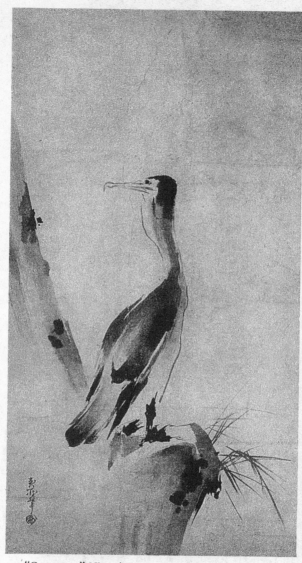

21. "Cormorant." Niten (Miyamoto Musashi).
Hosokawa collection. Tokyo.

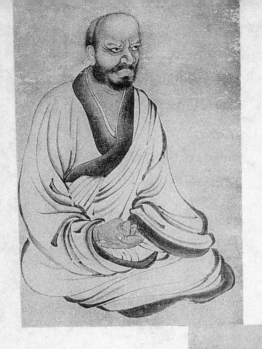

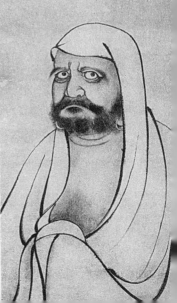

22. Triptych: "Rinzai, Daruma, and Tokusan." Dasoku. Collection of the Yotoku-in, Kyoto Prefecture.

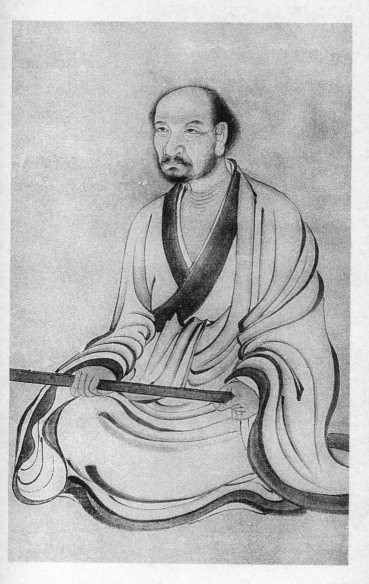

23. "Daruma." Hakuin. Hosokawa collection, Tokyo.

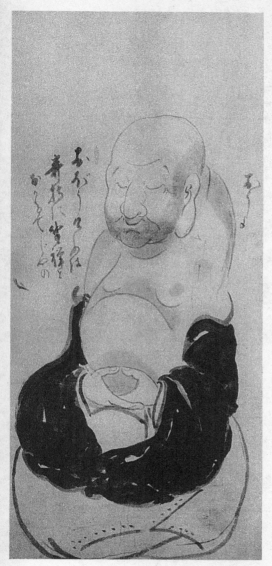

24. Self-portrait. Hakuin. Hosokawa collection, Tokyo.

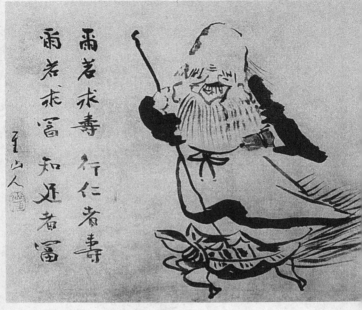

25. "Fukurokuju." Sengai. Seattle Art Museum.

the upper lids and the pupils, giving the eyes a peculiar force.

Among his many pictures of Japanese Zen masters, the most outstanding are those of Daito Kokushi, the founder of Daitoku-ji, which are in the Hosokawa collection. Particularly fine is the scroll of the founder as a barefoot beggar carrying a begging bowl and dressed in a straw rain-cape and a large straw hat. Another painting of Daito Kokushi shows him in his official position, wearing monk's garments and holding a rod. Most original are the round eyes and the distorted mouth, which seems to be letting loose a loud roar. Several other Zen masters were also represented by Hakuin, all treated in the same strange, yet personal manner. He also painted some self-portraits which give a vivid sense of his personality. In the one reproduced (Plate 24), he shows himself as a gentle, rather humorous man with a big nose and a very small smiling mouth. The upper part of the body, hunched and elongated, with the head sunk onto the breast, is painted with delicate lines and faint washes that are balanced by the black area of the robe. It is not pure chance that these works are admired today, for they resemble such contemporary expressionists as Munch and Nolde. All the elements of Zen painting are present, but they are carried to an extreme that gives Hakuin's work its individual character.

Sengai (1750–1837), another Zen master who was also original although in a lighter and more humorous vein, was active at the end of the Edo period. As the abbot of Shofuku-ji at Hakata, the oldest Zen temple in Japan, he was a prominent figure in Japanese Zen and, especially in his old age, was a fine calligrapher and delightful painter. His works often border on caricature and are really closer to *haiga,* the kind of painting developed by the haiku poets, than to *Zenga.* His subjects—folklore, religion, landscapes, animals, plants—were often painted in conjunction with some crazy verses of his own. Typical of his work is the delightful picture of Fukurokuju, god of longevity, who is shown standing on the back of a turtle (Plate 25). The brushwork is fresh and brisk and free,

creating a lively and rather amusing work. It is on this note that Zen painting drew to its close—a note of gaiety and charm, no doubt reflecting the decline which Zen had suffered in modern Japan.

Cha-no-Yu & Zen

OF ALL THE aspects of contemporary Japanese culture, the one which is most directly an expression of Zen ideals is *cha-no-yu,* or the tea ceremony, as it is known in the West. Originally practiced by monks in Zen temples, it has become for the most part a polite accomplishment for well-brought-up, traditional girls, but it still retains much of the Zen spirit, although those practicing it may be completely unaware of this debt. In fact the spirit of *cha-no-yu,* referred to as teaism by the late-nineteenth-century author Okakura in his *Book of Tea,* has so permeated the aesthetic culture of Japan that hardly any phase of Japanese life is unaffected by the peculiar kind of sensibility which is embodied in its tradition. Simplicity, restraint, and naturalness, combined with a love for the rustic and the homely, have become so integral a part of their heritage that the Japanese no longer think of these qualities as being especially Zen or specifically associated with the tea ceremony.

Although *cha-no-yu* as it exists today was developed by the Japanese, the habit of drinking tea was introduced from China by Zen monks who used it during their meditation as a stimulant to help keep them awake. The ritual drinking of tea, forgotten today in China, not only persists as *cha-no-yu* in Japan but shows an unexpected vitality in face of the Western thinking that has made such

inroads on Japanese culture. In fact, it might be said that as a counterreaction to the Westernization of the postwar period, cha-no-yu has had a certain revival both as a protest against foreign influence and as a reaffirmation of the national heritage.

Although the earliest record of tea drinking in Japan goes back to the Nara period in the eighth century, when the Emperor Shomu invited one hundred Buddhist monks to take tea in his palace, it was not until the Kamakura period that it became at all widespread. The monks of the Five Great Temples of the Zen sect brought tea seeds back from China, and growing tea plants became popular in the Uji district not far from Kyoto, a region which to this day is famous for the quality of its tea. The Zen teacher Eisai (1141–1215) is said to have been responsible for making tea popular in Japan by pointing out its beneficial effects in curing a variety of diseases.

The ritual drinking of tea, introduced by the Zen priest Dai-o in 1267, did not become important in Japanese culture until the Muromachi period when, under the Zen master Ikkyu (1394–1481) and especially his pupil Shuko (1422–1502), tea drinking was developed into an elaborate cult. Shuko taught the art of tea to the Ashikaga shogun Yoshimasa (1435–90), who became an enthusiastic chajin, or tea man. To this day the villa (known as the Togudo) in which he celebrated cha-no-yu (Plate 34) is preserved on the grounds of the Ginkaku-ji, or Silver Pavilion, in the northeastern outskirts of Kyoto, where Yoshimasa lived. Its tearoom (called the Dojinsai), which was the model for all later tearooms or chashitsu, was designed during the late fifteenth century by Shuko for Yoshimasa to practice cha-no-yu with his friends. So popular did the ceremony become that cha-no-yu parties were held at all hours of the day and night, and the taste of the tea devotees became so influential that the whole period might be said to reflect the spirit of cha-no-yu.

If Shuko was the founder of cha-no-yu, it was Rikyu, another Zen priest, who brought the ceremony to perfection. While the cha-no-yu parties of the Ashikaga shoguns had reflected the court life of the period, Sen-no-Rikyu

(1521–91) emphasized simplicity and economy. A thatched hut in a garden seemed to him a more desirable setting than a palace, and ordinary utensils, often of a kind used by peasants, appealed to him more than the splendid porcelains and lacquers used by the Ashikaga rulers. To this day tea masters are influenced by Rikyu, and it is his teaching which is considered the orthodox one. The most important modern schools, such as the Omote-Senke-ryu and the Ura-Senke-ryu, were found by his great-grandsons and are based on the canons he taught. Rikyu prescribed not just the form of the ceremony itself but the kind of utensil to be used, the design of the tearoom, and the type of garden surrounding the teahouse. To say that Rikyu was the most influential Japanese tea master is to understate his importance, for his ideas left a permanent mark on Japanese culture.

A native of Imaichi in Izumi Province, Rikyu took the name Sen from his grandfather, Sen-ami, an artist who had been a contemporary and intimate of Yoshimasa. The name Rikyu, suggested by his Zen master Kokei Osho of Daitoku-ji, comes from the phrase *meiri tomo ni kyu-su,* which means "fame and profit are both dispensed with." He is also known as Rikyu Koji, *koji* being a Buddhist term for "enlightened recluse." Interested from an early age in *cha-no-yu,* he studied under various teachers— notably under Jo-o (1503–55), who was the greatest tea master of the day. Rikyu became a favorite of the military dictator Nobunaga, and after the ruler's death, he won an equal place under his successor Hideyoshi. During the latter's rule as military dictator, *cha-no-yu* played an even greater role, and there were elaborate tea parties like the famous one in the pine groves of Kitano near Kyoto. Tea enthusiasts were invited from all over the country, regardless of rank, and asked to bring tea utensils of interest and beauty. Even during his military campaigns, Hideyoshi took time out for the tea ceremony, and as rewards to his retainers, he would give tea articles of great value. In all these matters Sen-no-Rikyu served as advisor to Hideyoshi, who asked him to revise the rules for *cha-no-yu.* His judgment in the choice of utensils, painting,

and calligraphy was considered absolute, and his position at the court of the great military ruler was that of the arbiter of taste.

How close Rikyu's teaching was to the spirit of Zen is best illustrated by the story that Professor Sadler recounts in his excellent study of *cha-no-yu*. "Once a certain person came to Rikyu and asked him what were the mysteries of Tea. 'You place the charcoal so that the water boils properly and you make the tea to bring out the proper taste. You arrange the flowers as they appear when they are growing. In summer you suggest coolness and in winter you suggest cosiness. There is no other secret,' replied the Master.

> 'Tea is nought but this.
> First you make the water boil,
> Then infuse the tea.
> Then you drink it properly.
> That is all you need to know.'

'All that I know already,' replied the other with an air of disgust. 'Well, if there is any one who knows it already, I shall be very pleased to become his pupil,' returned Rikyu."[35]

Today *cha-no-yu* is often an empty ritual in which every movement and every gesture is prescribed to the smallest detail, and tea masters vie with one another in their display of choice ancient utensils. All this is alien to the cult as Rikyu conceived it. To him, naturalness and simplicity were at the very heart of the ceremony, and many stories are told of how he chided people who used precious teacups or tea caddies, preferring ordinary objects because ornateness was considered not just vulgar but contrary to the spirit of *cha-no-yu*. This may seem strange in view of the magnificence of the Momoyama period, during which Rikyu lived, but it is precisely this dichotomy between the swashbuckling splendor of the military men and the calm restraint of the tea masters which, as Ruth Benedict has shown so convincingly in *The Chrysanthemum and The Sword,* is one of the outstanding characteristics of Japanese culture.

Wabi and *sabi* are the two key terms (neither of which has an exact English equivalent) used to express the peculiar spirit of the tea ceremony. *Wabi* means that which is simple, rustic, and serene. It is suggested by a thatched hut or an old farmhouse in contrast to what is fashionable and worldly. One of the famous books on the art of tea, the *Nambo-roku*, by Rikyu's pupil Sokei, says, "The spirit of wabi is to give expression to the Buddhaland of Purity altogether free of defilements, and therefore, in this roji (courtyard) and in this thatched hut there ought not to be a speck of dust of any kind; both master and visitors are expected to be on terms of absolute sincerity; no ordinary measures of proportion or etiquette or conventionalism are to be followed. A fire is made, water is boiled, and tea is served; this is all that is needed here, no other worldly considerations are to intrude. For what we want here is to give full expression to the Buddha mind. When ceremony, etiquette, and other such things are insisted on, worldly considerations of various kinds creep in, and master and visitors alike feel inclined to find fault with each other. It becomes thus more difficult to find such ones as fully comprehend the meaning of the art. If we were to have Joshu for master and Bodhidharma, the first Zen patriarch, for a guest, and Rikyu and myself picked up the dust in the roji, would not such a gathering be a happy one indeed?"[36]

The literal meaning of the term *sabi* is "mellowed by use" in contrast to what is new and shiny. Here again the emphasis is upon not being ostentatious but achieving a sense of calm which is conducive to contemplation and tranquillity. The aim of *cha-no-yu*, like the aim of Zen, is to create an inner quiet in which the still voice of our Buddha nature can be heard. Today, when *cha-no-yu* has largely lost sight of this goal, it has become little more than an intricate, minutely codified ritual, but once it was closely related to contemplative Buddhism and represented a turning away from the cares and business of the world in order to become, if only for a time, one of the hermit sages who found peace in contemplating the Tao. Everything connected with the tea ceremony is de-

signed to enhance this feeling of quietness and simplicity. The irregularly spaced flagstones in the garden path leading to the tea house, the thatched hut, the low awkward opening through which one enters, the dim room, not more than ten feet square, the plain wood used in the construction, and the smooth *tatami* matting all help create the spirit of *wabi*. The focal point in the interior is the alcove, or tokonoma, in which a scroll with a Zen saying, a poem, or a suitable picture is displayed. The painting, invariably executed in *sumi-e,* may show a Zen figure, a landscape, or a bird-and-flower subject—something appropriate to the time of year and the occasion. Beneath the scroll, on the raised floor of the alcove, there is an old piece of pottery or bronze which sometimes contains an unobtrusive flower arrangement, or there may be flowers in a bamboo container attached to the post of the alcove. While viewing the tokonoma, the guest listens to the sound of the water boiling in an old iron kettle, a sound likened to that of a breeze in a grove of pines. Kneeling in the small, plain, beautifully proportioned room, following a carefully prescribed ritual, and at length sipping a small amount of thick, bright-green tea, the guest even today experiences something of the spiritual peace that the tea ceremony is supposed to create.

The art form most favored by the tea masters was pottery, and many of the great treasures of the tea cult are ceramic vessels. The two shapes particularly important in the tea ceremony are the *cha-ire* or tea caddy, which contains the powdered tea (Plate 26), and the *chawan* or tea bowl (Plates 27 and 28). The shapes were not designed especially for the tea ceremony, but were borrowed from quite ordinary vessels. The oldest and most precious of the *cha-ire* were oil or drug bottles produced in Sung China, and the most celebrated tea bowls, valued so highly by masters like Rikyu and assiduously collected by Hideyoshi and his generals, were humble rice bowls which had been used by Korean peasants. So great was this love for the simple that pots which had misfired or had been mended were also treasured, while fine porcelains and ornately decorated wares were considered

inappropriate for the tea ceremony. Coarseness and irregularity were looked upon as particularly desirable. Rikyu himself attached no importance whatsoever to the age and value of the utensils so long as they had the qualities which the *chajin* so greatly prized.

Various shapes and types of pottery could be used for the tea ceremony. Many of them (especially during the early period of tea—that is, before the time of Rikyu) were imported from China and Korea, but later they were produced largely in Japan. Among the Chinese wares the tea masters preferred were the dark-brown *chien* ware, known as *temmoku* in Japan; the greenish celadon, referred to as *seiji;* and the cruder types of blue-and-white ware that the Japanese call *sometsuki.* Among the Korean bowls, the Ido wares were especially valued for their strong, simple shapes and the fine network of crackle which covers their surface. The colors of all these wares were subdued, in keeping with the spirit of *cha-no-yu,* while bright colors and rich designs were considered inappropriate.

Among the Japanese wares, the productions of the Seto kilns were the most famous during the early period, especially the works of Kato Toshiro, the supposed founder of the Japanese ceramics industry, who was celebrated for his *cha-ire.* The Japanese wares best suited for *cha-no-yu* were the tea bowls made by the Raku family of Kyoto (Plate 29). Fired at a very low temperature, with thick, soft bodies and dark tones, this ware is beautifully adapted to the tea ceremony, and has been prized by tea masters for centuries. This type of ware, which originated in the sixteenth century and was patronized by Hideyoshi, is still produced today, but it is the output of the first generations of Raku potters, during the Momoyama and early Edo periods, which is most highly esteemed. Many of these old pieces have individual names, such as Fujisan (the single most famous tea bowl, which was made by Koetsu in the early seventeenth century), and are officially designated as among the national treasures of Japan. Another famous tea ware which is outstanding for its unpretentious beauty is Shino ware, produced in the neighbor-

hood of Nagoya and noted for its strong, simple shapes and thick creamy glaze, which often has abstract designs in copper oxide (Plate 30). Oribe ware, made in the same region, is distinguished by the contrast between the gray or yellowish ground and the dark-green glaze often forming bold and original designs (Plate 31). Of the Korean-type wares, the best are those made at Karatsu in northern Kyushu, which are famous for their beautiful brushwork showing grasses and flowers (Plate 32), and Satsuma ware, produced at Kagoshima at the southernmost tip of Kyushu. Other kilns which made fine tea wares based on Korean models were the sites in the San-in district facing the Japan Sea, notably Hagi and Izumo, outstanding for the fine crackle, the subdued and lovely glazes, and the simple yet elegant shapes of their products. Typical of the taste of the tea masters is the fact that, in addition to the types discussed above, which were made especially for the tea ceremony, they also used wares from provincial kilns, made by local potters for their own use. These vessels, often crude and coarse, were regarded as particularly suitable for water jars and flower vases. They correspond to the Zen cult of the natural and the ordinary. The most outstanding is Bizen, with its beautiful reddish-brown clay which is fired without glaze (Plate 33), but Tamba, Shigaraki, and Iga are also much admired.

Though utensils made of ceramics were particularly treasured, other materials—lacquer, bamboo, iron—were also used. Lacquer was especially favored for the *cha-ire*. Among other articles made of lacquer were the incense containers as well as the bowls, dishes, and trays used for the *kaiseki*, the meal served before the tea ceremony. Bamboo was largely employed for the delicate spoons with which the tea is taken from the caddy and for the tea whisks used to stir the powder into the water. The ladle for dipping the water from the kettle was also bamboo, as were some of the flower vases, a custom established by Rikyu himself. No doubt bamboo was originally used because it was cheap and common, but today some of these bamboo flower containers and tea spoons—now old and celebrated—are considered priceless treasures. Among

the objects made of iron, the most important are the tea-kettles, which are prized for their strong, heavy shapes. The best are those made at Ashiya in northern Kyushu. Some are decorated in low relief, while others are completely plain or are covered with an abstract allover pattern. These various utensils combine simplicity with elegance, thus corresponding to the ideal of the *chajin*, who loved the natural and the unpretentious and yet, at the same time, cultivated a subtle, delicately discriminating taste.

Zen in Japanese Architecture

CLOSELY related to the spirit of the *chado,* the way of tea, is Japanese architecture under Zen inspiration, especially the teahouse or *chashitsu,* which in turn has influenced the Japanese house. Zen ideals have become so much a part of the general aesthetic tradition that the average Japanese is hardly aware that even the design of the house in which he lives is influenced by Zen thought. Yet if the history of the modern Japanese house is traced back to its beginnings in the Muromachi period, it becomes clear that its origin will be found in the buildings erected by the Zen abbots. The qualities which today seem peculiar to the Japanese aesthetic sensibility, such as simplicity, plainness, restraint, and severity of design, are ultimately derived from Zen sources. In fact, the whole feeling of calm and purity that we associate with Japanese architecture expresses the Zen spirit very beautifully. Other features of Japanese architecture which—although anticipated in Shinto buildings—were typical of Zen temples and teahouses are the closeness to nature, with the structure built as to be in harmony with its landscape surroundings, and the use of natural materials like unpainted wood, bark, straw, rushes, reeds, stones, and rice paper—all of which enhance the feeling of unpretentiousness which the Zen masters so admired.

Like practically everything else connected with this

form of Buddhism, the style of architecture used in the Zen temples was introduced from China during the thirteenth century. It was known as Kara-yo or Chinese style and was actually the official style of building used on the mainland during the Sung period (960–1279). Many of the famous Zen temples of Kamakura times, such as Kencho-ji in Kamakura (founded in 1253), and Engaku-ji in Kita-Kamakura (completed in 1281), were erected in this style. Unfortunately no completely authentic examples of Zen monasteries of this period have survived, so that it is necessary to reconstruct their appearance from old plans and drawings. The best preserved of the thirteenth-century Zen structures built in the Kara-yo style is the Shariden or Relic Hall of Engaku-ji (Plate 35), the only building at this site that withstood the disastrous earthquake of 1923. There are also some provincial examples, such as the Kaisando or Founder's Hall and the Kannondo or Kannon Hall, both at Eiho-ji in Gifu Prefecture, and the Butsuden or Buddha Hall at Kozan-ji in Yamaguchi Prefecture. In their construction, these buildings reflect their Chinese prototypes, and they do not have any features which could be considered particularly Zen, with the exception of the fact that they use plain unpainted boards. The outstanding characteristics of Kara-yo are a rather complex bracketing system, doors in the Chinese paneled style, and latticed windows with arched heads. These features are also found in the Zen temples of the Muromachi period, but they remained a distinctly Chinese contribution and never became universal even in Zen temples.

A more pronounced innovation occurred in the plan of the temple complex as a whole, for here real changes were dictated by the nature of the new religious conceptions. The emphasis was placed upon the *zendo* or meditation hall, where the monks gathered for their Zen exercises, while the traditional Buddha hall containing the sacred images, which had been the main building in traditional Buddhist architecture, was now of secondary importance since the ritual icons no longer had an important role in the worship. The size of the *zendo* varied, depend-

ing upon the number of monks in a given monastery, but the design was always that of a plain, rectangular building. The sides of the hall had raised platforms, three feet high and eight feet wide, which the monks used both for meditation and for sleeping, while the center was left empty for practising an exercise known as "sutra walking." In keeping with the cult of austerity, the space allotted to each person was only one mat—that is, no more than three by six feet. The monk's only bedding, summer and winter, was a large padded quilt, and his entire belongings consisted of priestly robes, a few books, a razor, and a set of bowls which were put in a travelling box. Since the Zen Buddhists regard the temptation of worldly possessions as one of the worst evils, the austerity practiced by the monks was an essential part of their discipline and was reflected in the bare, unadorned design of the interior. These features of the *zendo* which go back to the early Zen temples of the Kamakura and Muromachi periods, are still found in Zen monasteries today.

The general plan of the traditional Zen temple complex was usually organized along a central axis leading from the outer gate *(somon)* to the main gate *(sammon)*, to the Buddha hall *(butsuden)*, and the Dharma hall *(hatto)*. The abbot's quarters, known as the *hojo,* were usually in back of these main buildings. Various smaller structures, such as the kitchen, the bath, the lavatories and the library, stood at the sides of this main group without following any particular plan. Sometimes there was also a pagoda, but it was less essential than it had been in traditional temple design. The *zendo* or meditation hall was sometimes incorporated into the main axis, but more frequently it had a precinct of its own and was actually the spiritual center of the temple. In fact typical Zen temples, such as the great monastery of Daitoku-ji in Kyoto, consist of a whole cluster of subtemples and residences grouped loosely around the main buildings. These were used for private meditation and living quarters not only for the abbots and monks but also for guests who wished to devote themselves to the religious life and for old people who had withdrawn from the world in order to practice

meditation. While in most cases the architectural detail of these structures does not differ noticeably from that used in the buildings of other sects, the general spirit of these temple yards, with their serenity, cleanness, and simplicity (Plate 36) is profoundly Zen, and this aspect has had an incalculable effect not only on the further development of Japanese architecture, but also on the general aesthetic culture of the Japanese people.

The influence of Zen Buddhism was by no means restricted to religious architecture but extended to domestic architecture as well. The origin of the Japanese house as we know it today goes back to the late Kamakura and above all to the Muromachi period, when a new style of house, known as *shoin-zukuri,* replaced the traditional *shinden-zukuri* type, which had been popular with the Kyoto nobility of the previous period. This new type of house, which was characteristic of the austere and vigorous culture of the warrior class, was influenced by the residence of the Zen abbots, for the relationship between these two classes was intimate during both the Kamakura and the Muromachi period. One group, forming the intellectual elite of the nation, dominated the culture, while the other concentrated the military and political power in its hands; yet both the Zen priests and the military men had much in common, for each made a cult of rigorous self discipline, frugality, austerity, and boldness.

The outstanding traits of this new type of domestic architecture were features which to this day may be found in the Japanese house—the shoji or sliding screens with translucent paper panels; the tokonoma or *toko,* an alcove with a raised platform used for the display of works of art (in the priest's dwelling it would have been Buddhist scrolls or calligraphy); the *tana,* a shelf built into the wall (used for storing sacred texts in the monasteries); and the *shoin* (from which this style of architecture is named), a window with a desklike elevation used as a kind of study. In addition, there was the entrance hall or *genkan,* a feature still typical of the Japanese house. The arrangement of the rooms and the various parts of the building complexes was very irregular, not symmetrical

as it had been in the *shinden-zukuri* style of the Heian period. But the trait which was the most outstanding and also the most immediately related to Zen was the extreme severity of its design and the simplicity of its forms. The straight lines of the interior created geometric patterns of a very pure kind of beauty, and the materials themselves were simple and unadorned. The floors, which in the earlier houses had been wood, were now *tatami*, consisting of a straw base covered with reed matting; the walls were made of wood and plaster; the ceiling was of plain wood; and the scrolls in the tokonoma, in keeping with Zen artistic ideals, were usually painted in monochrome so as to blend in with the soft tones of the rooms. All these features are found both in the abbots' quarters and in the houses of the aristocracy, but there is no doubt that they can be traced back to the Zen monasteries.

The most outstanding surviving examples of the domestic architecture of the Muromachi period—that is, of the fourteenth and fifteenth centuries—are two famous Kyoto buildings, the Kinkaku-ji or Golden Pavilion and the Ginkaku-ji or Silver Pavilion (Plate 37), with its small but significant Togudo (Plate 34). Both of these elegant structures, which today are part of temple complexes, were originally built as villas for the Ashikaga shoguns. They contain all the characteristic features of the new style—the *shoin,* the tokonoma, the *tana,* and, in the upper floors, the arched windows and paneled doors of the Karayo style. Even more important, both for the development of domestic architecture and the design of tearooms, was the Togudo, a small building which was used by the Ashikaga ruler Yoshimasa as a temple for his private devotions. It is a modest structure, yet since it contains the first tearoom (which already consists of the traditional four and a half mats), it is a landmark in the history of Japanese architecture. Combining a religious function with that of serving as a house, it illustrates the close connection that existed between the Zen temple, the Japanese house, and *cha-no-yu,* all of which were permeated by the same spirit.

Although the first room intended specifically for tea

ceremony had been designed by Shunko at the end of the fifteenth century, the full development of teahouse architecture did not take place until the sixteenth century. During the Momoyama period (1573–1615), the rustic style of building characteristic of teahouse architecture emerged as a kind of antidote to the splendor of official architecture. In an age dedicated to military exploit and worldly ambition, the spirit of tea helped to maintain a balance between the two sides of the Japanese character: the world of the samurai, with its emphasis upon action and courage, and the world of the Zen priest, with its concern for contemplation and spiritual discipline. Excellent teahouses are still built today, but the finest are from the late sixteenth and seventeenth centuries, when *chano-yu* was at its height.

The unique quality of this type of architecture is perhaps best summarized by the modern Swiss architect Werner Blaser. "The spirit of the tea ceremony has entered completely into the teahouse where it is celebrated. The four principles of Sen-no-Rikyu (1521–1591), the creator of the classical tea ritual, are: harmony-reverence-purity-silence. The rooms grow out of these principles. Reverence, purity, and silence speak to us from all the surfaces enclosing the room, even from the very utensils of the tea ceremony itself. But this harmony is not the result of mathematical calculation; it is seen through a harmony of spirit. Such structures rest in equilibrium because there is perfect poise in the minds creating them, and mental balance has never been achieved through calculation. In short we find in the Japanese temples and the dwellings and tea houses no technique expressible in figures but only in terms of art. And perhaps we should do well at this point to recall that our word Technology is derived from the Greek word Techne, which meant in the first place the dexterity of the craftsman and subsequently art, and that the essence of technology should not be far removed from art. The Japanese temple and the Japanese tea house represent the art of building in its truest sense and should be distinguished from all ordinary architecture."[37]

There are many types of tearooms, but basically they fall into two categories: *kakoi* or those which form part of a larger building and *sukiya* or those which form separate houses built in the rustic style of a peasant's hut. The latter type originated with Sen-no-Rikyu, who was dissatisfied with the luxury and refinement that had grown up around the tea cult during the Ashikaga reign. The teahouse is usually a simple, modest structure, set aside from the main buildings of the monastery or private dwelling behind a wall or bamboo fence or hedge. A stone path or *roji* leads from the gate to the hut, which is entered through the *nijiriguchi,* a small entrance so low that the guest has to crawl in—an act indicating that pride and social distinction are left behind when one enters the world of tea (Plate 38). The tearoom itself is extremely plain—usually no more than four and a half mats in area and sometimes even smaller, Rikyu himself having designed one of two mats. The measurements of the tearoom have been fixed by tradition and are usually followed even today. The materials used are natural wood, a plaster of plain gray mud and sand on the walls (the lower part of which may be papered), *tatami* matting on the floor, and rice paper in the sliding screens. In the center or at the side is a square hole containing the hearth, and in one corner is the tokonoma. This ceiling is made of strips of wood, bamboo, reeds, and bark. Otherwise the room is bare, suggesting the Zen ideal of nothingness, and the light entering through the small windows—a light that is soft and subdued—increases the feeling of tranquillity.

There are many fine examples of such teahouse architecture, as well as various buildings which, though not intended for this purpose, are deeply imbued with the spirit of the *chashitsu,* but the one monument that comes to mind when one thinks of this phase of Japanese architecture is the Katsura Detached Palace near Kyoto. The most famous of the teahouses at this site is the Shokintei or Pavilion of the Rustling Pines and the Sound of the Lute. Here the feeling of simple elegance is beautifully combined with the spirit of *wabi,* for every detail is per-

fect, yet the effect of the whole is completely unpretentious and natural. There are other celebrated teahouses on the grounds of Buddhist temples, such as the *chashitsu* designed by the great tea master Kobori Enshu (1579–1647), who, although a daimyo, became a Buddhist monk. The most famous of these are located in the compound of the Zen temple of Daitoku-ji in Kyoto and are known as the Mitsu-an of the Ryuko-in and the San'unsho and Bosen of the Koho-an (Plate 39). Compared to *chashitsu* in the more rural style of Rikyu, these structures are somewhat more sophisticated and refined, reflecting the new spirit of the Edo period.

Although the teahouses played a rather minor part in the whole of Japanese life, since they primarily affected the Zen priests and the *chajin,* their influence has been felt throughout the architecture of Japan, and it is not too much to say that through the teahouse, the spirit of Zen has permeated all of Japanese architecture. Again, as in other cases, the Japanese, who prefer the simple lines and empty space of their own houses in contrast to the cluttered and often ornate interiors of the West, are not consciously thinking in Zen terms but have simply absorbed these ideals as part of the climate of opinion in which they grew up. Yet this type of aesthetic sensitivity is very much an expression of Zen ideals and indicates how deeply Japanese culture is imbued with the thinking of Zen masters. In recent years this influence has been even more widespread, for the principles of Zen-inspired architecture have begun to influence Western architecture as well. Through such masters as Frank Lloyd Wright with his emphasis upon the organic union of the house and its setting, Walter Gropius with his theories of the functional nature of the design, and Ludwig Van der Rohe with his cult of simplicity and austerity, the ideals of the Japanese builders, many of whom were Zen monks or worked for Zen temples, have influenced architecture throughout the world.

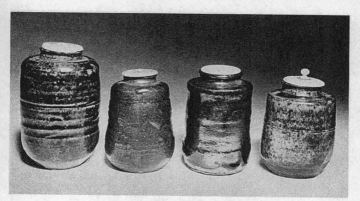

26. Seto tea caddies. Collection of the author.

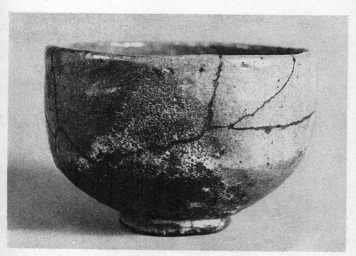

27. Red Raku tea bowl: "Haya-fune."
Private collection, Japan.

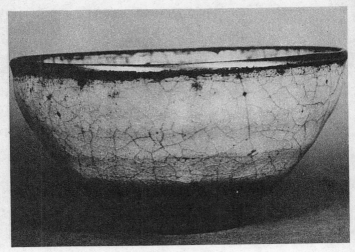

28. White *temmoku* tea bowl. Private collection, Japan.

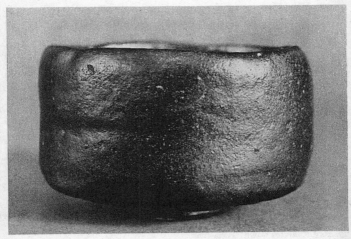

29. Black Raku tea bowl: "Shunkan." Private collection, Japan.

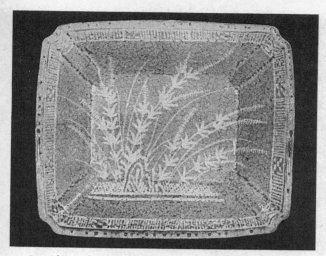

30. Gray Shino cake plate. Momoyama period (16th century).
Seattle Art Museum.

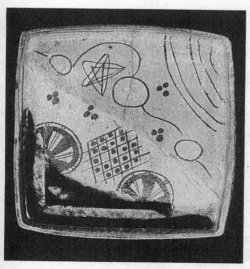

31. Oribe cake plate.
Seattle Art Museum.

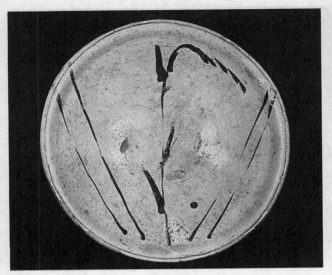

32. Karatsu bowl. Momoyama period (16th—17th century).
Seattle Art Museum.

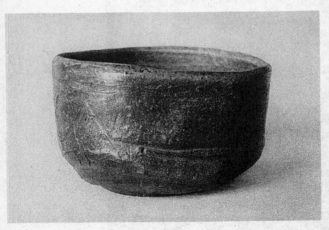

33. Old Bizen tea bowl. Private collection, Japan.

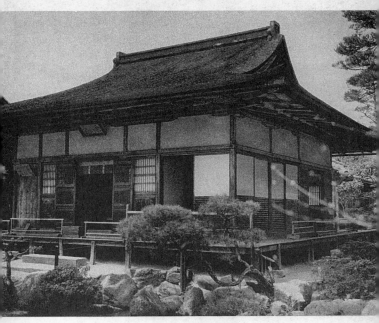

34. Togudo. Ginkaku-ji, Kyoto.

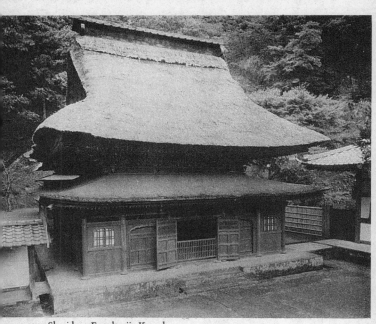

35. Shariden. Engaku-ji, Kamakura.

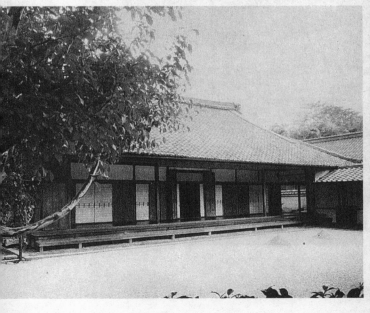

36. Abbot's residence. Daisen-in, Daitoku-ji, Kyoto.

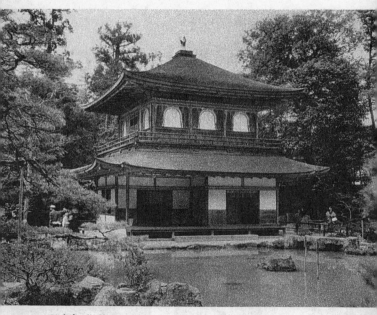

37. Ginkaku-ji. Kyoto.

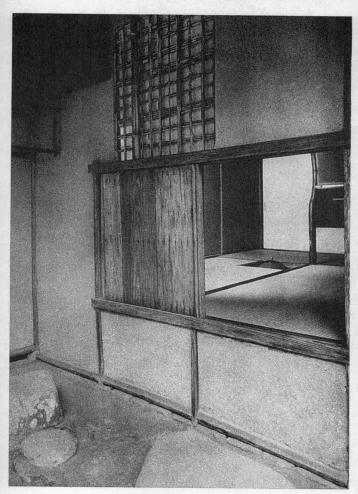

38. Entrance to tearoom. Koto-in, Kyoto.

39. Tearoom. Koho-an, Daitoku-ji, Kyoto.

40. Stone garden. Ryoan-ji, Kyoto.

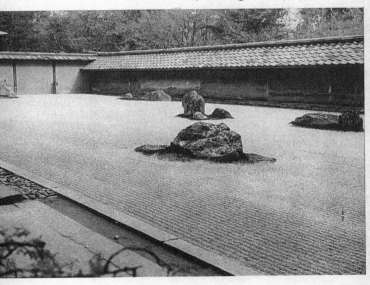

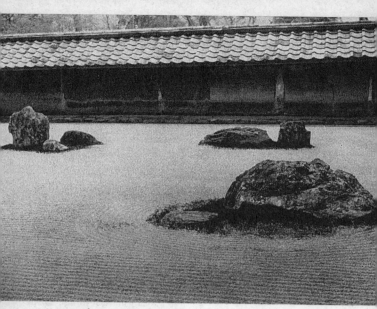

41. Stone garden. Ryoan-ji, Kyoto.

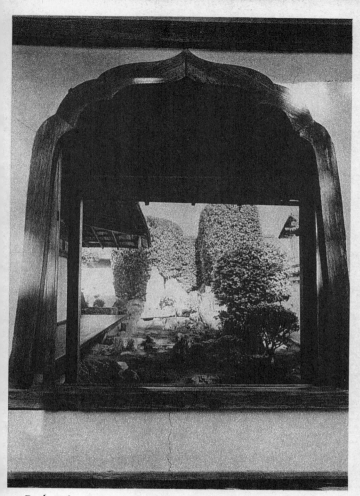

42. Rock garden. Daisen-in, Daitoku-ji, Kyoto.

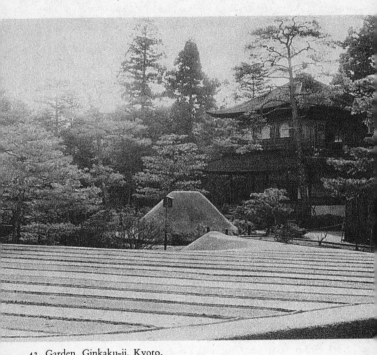

43. Garden. Ginkaku-ji, Kyoto.

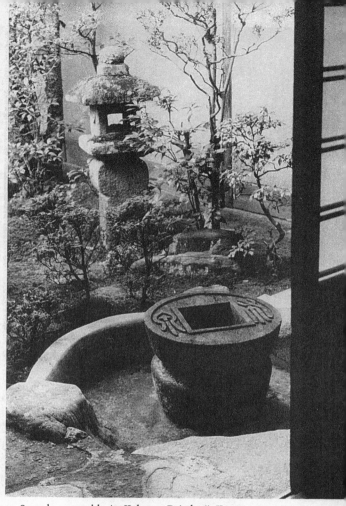

44. Stone lantern and basin. Koho-an, Daitoku-ji, Kyoto.

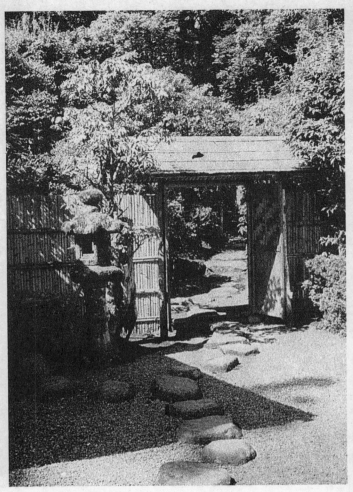

45. Stone path and gate. Kanden Tea House, Matsue.

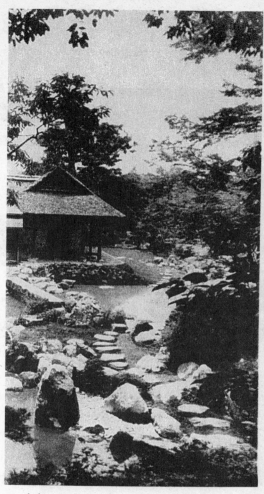

46. Shokin-tei. Katsura Detached Palace, Kyoto.

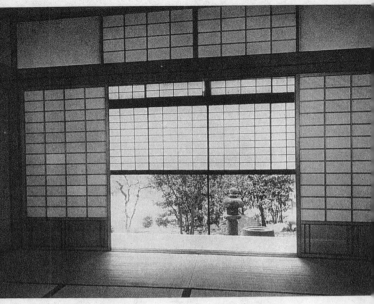

47. Tearoom with view of garden. Koho-an, Daitoku-ji, Kyoto

Zen in Japanese Gardens

ONE OF THE most distinctive features of Japanese culture is the importance of the landscape gardens. Unlike the English parks, which tend to be mere copies of nature, or the French gardens, which superimpose a completely arbitrary design on the natural forms, the Japanese garden represents an artistic arrangement of nature. As the late Langdon Warner said, "The fundamental thing about Japanese gardens, and what sets them apart from any gardens of the civilized world, is usually lost sight of by Westerners. It is the fact that the art was definitely used in China and Japan to express the highest truths of religion and philosophy precisely as other civilizations have made use of the arts of literature and painting, of ritual dance and music. . . . This being so, it is proper to consider, so far as Westerners may, something of the spiritual symbolism that has been expressed in the gardens laid out by Zen philosophers and has filtered down from them to the gardens made for and by laymen."[38]

Characteristically enough, the *Emposho* (Book of Gardens), one of the earliest and most influential of books on garden design, was written by a Zen priest of the Kamakura period, and many of the most celebrated gardens were designed by Zen priests on the grounds of Zen temples. This close relationship between Zen Buddhism and the landscape garden is particularly noticeable during the

Muromachi period, when a more abstract conception was introduced. The typical Muromachi garden was symbolical and small, representing a kind of artistic re-creation of nature rather than a piece of nature itself. It was intended as a retreat for meditation, not a park where one might take a walk or go picnicking or boating. In keeping with their purpose, Japanese gardens are very subdued and show the same economy of means that was characteristic of all other phases of Japanese art inspired by Zen Buddhism. There are no bright colors or masses of gorgeous flowers—instead, rocks, sand, water, trees, and green shrubs are used. Suggestion is preferred to explicit statement, so that water is sometimes symbolized by white sand, islands by rocks, and woodlands by dwarf trees or shrubs. The houses or tea huts are often half hidden by foliage, and the steppingstones—in contrast to the straight gravel paths of the West—are spaced irregularly and surrounded by moss or grass. Nature is brought close, at once mysterious and intimate, and the house is seen in part rather than all at once in a direct view.

This Zen influence in Japanese garden design came from China during the Kamakura period, but like so many other Chinese influences, it developed and flourished in Japan long after it had ceased to show much vitality in the country of its birth. Today the art of landscape gardening has all but disappeared in China, but it still continues as a major art form in Japan. The person responsible for introducing this kind of garden was the Zen priest Muso Kokushi. Several of the outstanding gardens of the fourteenth century were designed by him, and at least two, one at Saiho-ji and one at Tenryu-ji, both of them in the vicinity of Kyoto, are still preserved in their original form. In these gardens Muso gave visual expression to the ideal land of Zen as described in the *Hekiganroku* (Pi-yen-lu), a Chinese book on the spirit of Zen. The natural features of Muso's landscape setting are skillfully utilized in constructing an ideal garden with beautiful trees, various grasses and shrubs, soft moss, a large pond, small islands, picturesque rocks, and several pavilions. The garden is

not thought of as a place for pleasure but as an integral part of the Buddhist establishment in which certain philosophical and religious truths of Zen as seen by the great Ch'an masters are expressed.

Another strong influence on garden design was Chinese-style ink painting, and it has often been said that the gardens of the fifteenth century are nothing but *sumi-e* pictures translated into another medium. In both, the artist attempts to express nature in symbolical terms, using a kind of artistic shorthand. Characteristically enough, one of the most famous treatises on this subject, the *Tsukiyama Teizo-den* (Making of Hill Gardens), was written by the famous ink painter Soami, who was also an outstanding garden architect. In describing the construction of gardens and the spirit which inspired them, he says, "Even in a limited area, a landscape suggestive of the heart of the mountain or a deep ravine can be created, but only by an expert. Take for instance the case of the waterfall. If a waterfall is exposed to full view from the top to the bottom, it will appear low and add very little to the scenic effect. But if the upper part of it be concealed by trees, the middle part partially hidden by projecting rocks or by a branch of a tree, and the basin have a growth of grass or plants, the fall is not exposed in its entirety, and may give the impression of being of a great height. It is the same with the pond . . . too great a stress cannot be placed on the importance of the dignity or the spiritual quality of nature represented. Caution should be taken not to be too anxious to overcrowd the scenery to make it more interesting. Such an effect often results in a loss of dignity and a feeling of vulgarity. One's heart and mind should be concentrated on the profundity of nature, and there should not be any suspicion of frivolity in one's attitude towards it."[39]

Among the gardens traditionally attributed to Soami, the finest is the famous stone garden at Ryoan-ji in Kyoto (Plate 40). Today this attribution is no longer generally accepted, but even if Soami did not design it himself, there is no doubt that it reflects his teaching, since it was made at the time when he was acting as artistic advisor

to the Ashikaga shogun Yoshimasa. Part of a famous Zen temple, it expresses the ideals of this sect in their purest form and may be described as the most typical of all Zen gardens. In contrast to earlier designs, which had used water and trees, this is a dry garden consisting of white sand and rocks, a conception almost startling in its austerity and so remote from Western ideas that it bears no relation to anything that a Westerner would call a garden. Yet these extraordinary limitations are exactly what gives this work of art its unique quality, for the designer, instead of using nature literally, suggests it by means of symbols. The sand, raked into a formal linear pattern suggesting waves, is meant to represent the sea, while the rocks, which are scattered at irregular intervals over the small garden, are thought of as islands (Plate 41). There are fifteen stones, which are set up in groups of five, two, three, two, and three. It is the careful arrangement of the rocks and their relationship to the sand and to the wall surrounding the garden that is all important. Like the abstract artist of today, the designer reduced the natural forms to their simplest terms, composing them in so beautiful and moving a way that it is not surprising that this Zen garden enjoys such fame among Japanese and Westerners alike.

Closely related to the Ryoan-ji garden, and also dating from the very beginning of the sixteenth century, is the rock garden at Daisen-in, one of the smaller monasteries attached to the great Zen temple of Daitoku-ji (Plate 42). It is also a dry garden in which water is suggested by sand, but its shape and design are very different. Laid out in bands along the north and east sides of the *shoin* building, it is even smaller than the garden at Ryoan-ji. Its main elements are the upright rocks representing cliffs and waterfalls, the flat horizontal stones indicating boats and bridges, the white sand symbolizing a stream, and a group of clipped trees that are supposed to suggest distant mountains. The whole composition is believed to resemble a painting by a famous Sung master such as Ma Yuan or Hsia Kuei, with sand for the silk or paper, and rocks the equivalent of areas of black ink. Here again, the

shape, quality, and size of the rocks were of the utmost importance, and stones suitable for such gardens were often hauled from great distances at considerable expense. Some teachers went so far as to maintain that the proper selection and placement of rocks was the chief consideration in constructing a garden, and that trees and shrubs were only secondary. Usually a large portion of the stone is buried, so that only the part most suitable for the effect is visible. The beauty of the irregular and varied shapes, the texture of their surface, often covered with moss, and their relationship to one another are not accident but the end-product of the most careful and sensitive choice. The result is an art of a very high order in which sand, rocks, trees, and moss are used just as effectively as a painter uses silk and Chinese ink.

A third outstanding example of a Zen-inspired garden from the Muromachi period is that of the Silver Pavilion on the grounds of the Jisho-ji. Built in 1480, it was originally a part of the Higashiyama estate of the Shogun Yoshimasa, but at his death the villa and its garden were turned into a Buddhist temple and have been preserved as such to the present day. Although certain changes were made, notably in the pond and the lower part of the garden, it has recently been restored as far as possible to its original form. In contrast to the gardens at Ryoan-ji and Daisen-in, this one is built around an extensive pond planted with lotuses and containing islands with small bridges leading to them, as well as picturesque rocks and numerous trees and shrubs. Another interesting feature is a cone-shaped, flat-topped sandy hill, known as Koge-tsudai, or Moon-Viewing Terrace, which is said to have been used for studying the effect of moonlight upon the garden (Plate 43). The upper part of the garden, which was excavated in recent years, shows interesting rock formations and beautiful stone-paved paths, along with a bubbling spring of the purest water (used for the tea ceremony) and hills planted with pines, azaleas, and maples. Far more extensive and using the natural appearance of the landscape rather than a symbolical design, this type of garden, which became very popular during the fif-

teenth and sixteenth centuries, is less severe and yet just as beautiful and artistic as the stone gardens. Similar examples using trees, rocks, and ponds as the main elements are found at Rokuon-ji, popularly known as Kinkaku-ji, or Golden Pavilion, and at Toji-in, both of which are also in Kyoto. This type of pond garden continued to be popular during Momoyama and Edo times, with the famous garden at the Sambo-in of Daigo-ji the outstanding example from the former period, and the extensive garden at the Katsura Detached Palace the most illustrious from the latter.

Another type of garden was the *roji,* or teahouse garden, which was developed during the Momoyama period. Like *cha-no-yu,* this form of garden combined naturalness with simplicity and was deeply indebted to the spirit of Zen. The most famous of the *roji* were the creations of tea masters, and it is Sen-no-Rikyu himself to whom its origin and early development are traditionally ascribed. Small in scale and essentially little more than a garden path leading from the gate to the entrance of the tea hut, the *roji* are thought of as a dependent and necessary part of the *chashitsu* or teahouse. They were never looked upon as complete compositions like the stone gardens but were meant to be experienced section by section as one moved along the path. Their scale is a natural one, and great emphasis was put on a casual appearance rather than self-conscious artistry, this again very much in the spirit of Zen. A story told about Rikyu illustrates this point very well. "Rikyu once went with Doan to see a certain acquaintance, and when they came to the middle of the roji, Doan pointed out the antique-looking gate, remarking, 'That's interesting, it gives the path a solitary appearance.' But Rikyu shook his head. 'I don't think so,' he replied. 'This looks as though it had been brought from some mountain temple a long way off and the labor required to bring it must have cost a lot of money. A rough wicket gate made by a craftsman does give a really quiet and lonely look to a garden, but this sort of thing shows us what kind of tea this gentleman practices.' "[40] Another story about Rikyu relates that when his son had carefully

swept the path, removing every leaf and twig not once but twice, Rikyu declared himself dissatisfied, walked over to a maple bright with autumn colors and shook it, scattering red leaves over the garden path. In this way he combined the most exquisite artistry with a completely natural appearance.

The essential features of the tea garden are the stepping-stones leading from the gate to the tearoom, the old moss- and lichen-covered stone lanterns, and the water basin (Plates 44 and 45). The first are particularly important, not only from a utilitarian point of view but also for the beauty of their irregular spacing. Here again the seemingly informal design of the path is very much in the spirit of Zen. It usually leads from the outer gate to the *sotoroji* or outer garden, then past the *yoritsuki* or small cottage for waiting and the *koshikake* or roofed wooden arbor, where the host meets the guests. From there the path goes to the middle gate, past the water basin (in which the guest washes his hands) to the teahouse. The path between the waiting arbor and the tearoom is usually no longer than twenty feet, but every tree and stone is carefully placed to add to the beauty of the view. The trees are evergreens such as pines, Japanese cedar, cryptomeria, and camellia. Beneath them are shrubs, ferns, bamboo, and moss. The feeling, like that of *cha-no-yu,* is one of quietness and peace (Plate 46).

Though no tea gardens designed by Rikyu have been preserved in their original form, many such gardens are traditionally attributed to him, and others are said to be by such celebrated tea masters as Furuta Oribe, Kobori Enshu, and Oguri Sotan. The most famous, perhaps, are the tea gardens at the Katsura Palace, which have been traditionally ascribed to Enshu. Many fine gardens from the Momoyama and Edo periods still exist, such as the tea gardens of the Omote-Senke and Ura-Senke schools of *cha-no-yu* (designed by the son and grandson of Rikyu), and the garden of the Koho-an (Plate 47) and Shinju-an monasteries of the great Zen temple Daitoku-ji.

During the Edo period (and even more in modern times), gardens were no longer so closely connected with

Zen temples, and professional gardeners, rather than Zen priests and tea masters, designed them. In fact, it was first for daimyos of feudal Japan and then for the barons of commerce that the most outstanding later gardens were designed, and though they used the same elements introduced by earlier garden masters, their function was wholly secular and their quality quite inferior. Two of the few modern attempts which still have something of the old Zen spirit are the dry gardens at the famous Zen temple of Tofuku-ji in Kyoto. Here, in imitation of Ryoan-ji, are two fascinating stone gardens, one consisting of nothing but raked sand and variously shaped upright rocks, and the other, which is behind the abbot's residence, a checkered pattern of flat stones, moss, and white sand. Although they fall short of the great Muromachi gardens, they express the same Zen-inspired view.

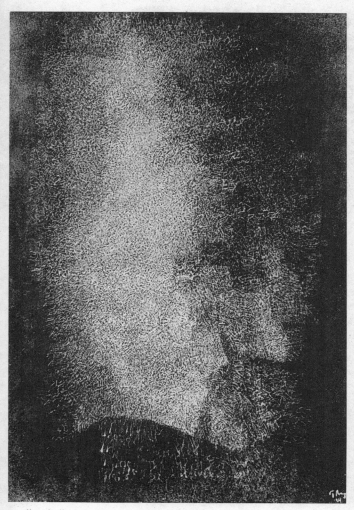

48. "Night." Mark Tobey. Collection of
Marian Willard Johnson, New York.

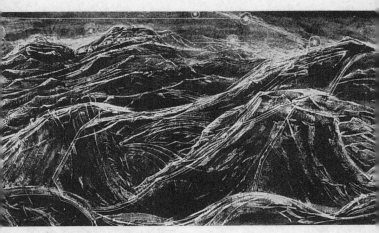

49. "Black Waves." Morris Graves. Room of Contemporary
Art Collection, Albright Art Gallery, Buffalo, New York.

50. "Still Life." Julius Bissier. Collection of the artist, Hagnau, Bodensee.

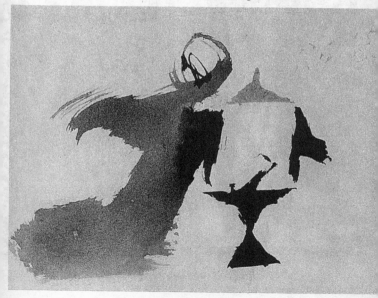

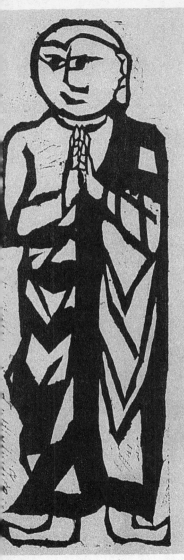
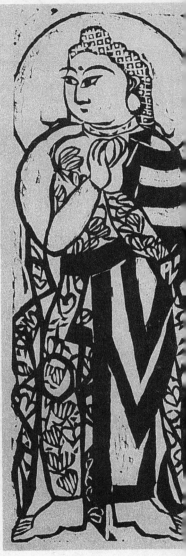

51. "Ragara" and "Monju." Shiko Munakata. Willard Gallery,
New York (photograph by Museum of Modern Art, New York).

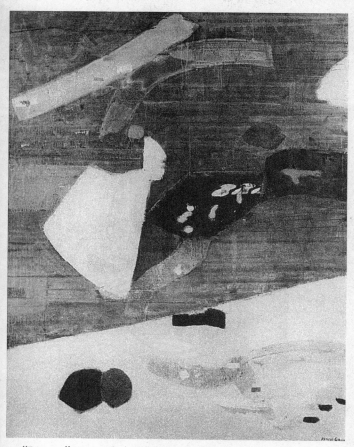

52. "Dynasty." Kenzo Okada. Albright Art Gallery, Buffalo, New York. Gift of Seymour H. Knox.

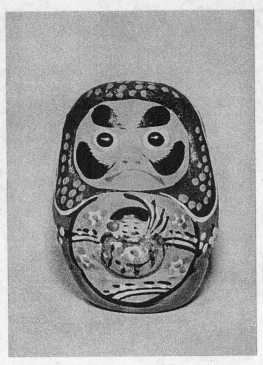

53. Daruma doll. Modern Japanese folk art.

Zen & Modern Art

ZEN, DORMANT for so many years, has not only experienced a revival in Japan but has also begun to influence the West. Zen abbots are touring the United States, Zen groups are forming in various parts of the world, Zen scholars are teaching at leading universities, Zen ideas are being discussed in Greenwich Village and among the beatniks in San Francisco, and books on Zen are having a brisk sale, just as works on existentialism did a decade ago. Serious young Westerners have even gone to Japan to study in Zen monasteries, submitting themselves to the exacting discipline in order to find an answer to the puzzle of human existence.

Suzuki, in commenting upon this phenomenon in his essay on Zen in the modern world, says, "Modern men are indeed groping in the dark which envelops the birth pangs that usher in a new age in all fields of human activity. Some of them, independent and original, revolt against liberalism and philistinism, communism and despotism, industrialism and automation, science and technology—which characterize the modern world of cheap, shallow intellectualism. But those of the 'Beat Generation' are not fully conscious of why they rebel or what they propose to do; they do not know their inner Self which is moving in the deep unconscious; they do not know that there is something in each of them, in-

dividually and collectively, prodding them to go on and they cannot intellectually determine what it is. But if they come to feel and find this mysterious something their 'new Holy Lunacy' will cease; they will just rest satisfied with themselves and with the whole world confronting them. It goes without saying that this satisfaction is not sheer passivism or doing-nothing-ness."[41]

Some authors (such as Professor Robert Hawkins in his article "Contemporary Art and the Orient"[42]) have tried to relate modern art to Zen; while others have re-examined traditional works of Japanese art in order to find in what way they are influenced by Zen, as Walter Gropius did in relationship to the Katsura Detached Palace,[43] and the young American painter and printmaker Will Petersen has done in relationship to the stone garden at Ryoan-ji.[44] Still others have examined the writings of Zen masters to find out what principles of art could be considered typically Zen. Outstanding among these is the Zen Buddhist abbot Hoseki Shinichi Hisamatsu, whose article "Seven Characteristics of Zen Art" appeared in the avant-garde abstract art magazine *It Is* and whose book *Zen and the Fine Arts* is the best thing of its kind written in Japanese.[45] In Germany the scholar Kurt Brasch devoted a whole book to the great Zen master Hakuin and the art he produced,[46] while his son contributed an article on the same subject to the English art periodical *Oriental Art*,[47] and Suzuki wrote an essay on the Zen painter Sengai and the relationship of Zen and art for the *Art News Annual*.[48]

Not only scholars and writers have delved into Zen and pondered its relationship to the visual arts, but also many creative artists have studied both the spirit and technique of Zen painting in order to use the insight they gain in their own work. Among those most deeply versed in Zen are Mark Tobey and Morris Graves, two West Coast painters from the Seattle area. Members of a Northwest school of art which is oriented towards the East, they look to China and Japan for inspiration rather than to New York or Paris. Both have lived in the Far East, and throughout their lives, have been enthusiastic students

of Oriental religion and philosophy. To them the calligraphy and ink painting of China and Japan are just as familiar as the oil painting of the School of Paris, and significantly enough, both have done their major work in the water-color medium. In fact, in 1934 Tobey (who was born in 1890) actually lived in a Japanese Zen temple, and spent several months in China in order to study Chinese calligraphy. In 1956 Graves also visited Japan. For many years prior to that, he had been a student of Far Eastern art and Zen philosophy, notably during his stay in Honolulu when he had been granted a Guggenheim fellowship for study in Japan but had been unable to go there because of the restrictions on travel during the immediate postwar period.

Tobey, twenty years older than Graves, who was born in 1910, first directed Graves's attention to Oriental art. Although Tobey never became a Zen Buddhist but has been a lifelong follower of Bahai, the modern Persian religion which teaches a new universal faith, he is close to Zen thinking and has been influenced both by Zen ideas and by Zen art. As his biographer Collette Roberts says, "Tobey has an intuitive Zen sense of existence that harmonizes with his Quaker heritage. He refers us to Watts's book, *The Way of Zen,* but does not wish to comment on Zen. That Tobey's work, essentially reflective, has found in and through the Orient a means of expressing the inexpressible—has found a language—is a certitude."[49] Tobey's white-writing paintings are deeply imbued with Zen, for like the calligraphy of the Zen masters, they express the inner self and are no longer concerned with outer form alone. Like the Zen painters, Tobey is a mystic intent on his inner vision rather than on the outer appearance of the world around him (Plate 48). As he once said, "The dimension which counts for the creative person is the space he creates within himself. The inner space is closer to the infinite than the other, and it is the privilege of a balanced mind—and the search for equilibrium is essential—to be as aware of inner space as he is of outer space."[50]

Graves is also a mystic who feels that since "Zen stresses

the meditative, stilling the surface of the mind and letting the inner surface bloom,"[51] it helps him to perceive the ultimate reality. Like the Zen artists, Graves believes in creating out of his inner self and sees his art as a private act of fulfillment. Far removed from the great urban centers of culture, he lives close to the earth and tries to express his relationship to the universe through the birds, animals, and plants that he paints. To him they are magic symbols of reality—birds of the inner eye, as he called one of his pictures, or spirit birds, as another is entitled. As Graves once said, "I paint to evolve a changing language of symbols, a language with which to remark upon the qualities of our mysterious capacities which direct us towards ultimate reality.

"I paint to rest from the phenomenon of the external world—to pronounce it—and to make notations of its essence with which to verify the inner eye."[52] Like Tobey, Graves does not imitate Oriental art, although its influence is evident in his work. Instead of copying, he turns to the same sources, to explore his inner self, which is to say the Tao of the Zen mystics (Plate 49).

Of the contemporary European painters, the one who is closest to Zen in spirit is the German artist Julius Bissier, who was born in 1893. Like a true Zen follower, Bissier lives in a small village on Lake Constance, remote from the confusion and rivalry of art centers. His small masterpieces are gradually winning him a place in the art world, leading to a showing at the Venice Biennale of 1960. Although he has never been in the Far East, Bissier has for many years been deeply influenced by the art of China, to which he was introduced by his friend Ernst Grosse, the German Sinologist and art historian. Characteristically enough, his first mature works are calligraphic ink paintings, representing what he calls life symbols. The black forms against the empty paper resemble some of the modern abstract calligraphy that is being produced in Japan today. Since 1955 Bissier has been exhibiting with a Munich artists' group who call themselves "Gruppe Zen," which is trying to create in Europe that awareness of the essence of being and harmony with the cosmos

which the artists of the Far East possessed. During these years Bissier has been painting a series of small pictures, both in water color and egg tempera, which he calls songs—delicate lyrical creations of rare sensitivity and beauty.[53] He refers to them as abstractions, and so they are, but they are closer to Paul Klee and above all to such Zen pictures as Mu-ch'i's "Persimmons" than they are to the work of Mondrian or Kandinsky (Plate 50). Some of the forms resemble fruits or vases, plants or stones, sun and moon, cosmic shapes which reveal in a poetic and abstract manner the nature of the universe. Here again Bissier does not imitate either the style or the technique of the Zen artists but creates out of a similar moment of awareness and thus achieves effects which are close to those of the great Zen painters.

Many other modern artists, although perhaps not consciously Zen, reflect the influence of Zen thinking or at least show that they are trying to express similar sentiments. When the French painter Manessier says, "Nonfigurative painting gives the painter the opportunity to discover the essence and to be able to express the inner self,"[54] or when the American sculptor Lassaw speaks of "an awareness of the universe" directed unconsciously by what he believes to be the "profoundest levels of his being," then one can hear the voices of the Zen masters who saw the nature of artistic expression in similar terms.[55] Small wonder, therefore, if essays on Zen and paradoxical Zen tales are enjoying a great popularity among abstract artists.

Another phase of Zen—the emphasis upon the spontaneous, the nonrational and the intuitive—strikes a sympathetic note in many a modern artist. When Langdon Warner says that in Zen painting "the technique thus evolved was a shorthand in which not only the subject matter but the very manner of the brush stroke came to be a most expressive vehicle of meaning,"[56] he seems to be talking about today's action painters. Even closer to their way of thinking is a story about the Chinese monk painter Fang I-chih of the early Ch'ing period. "After the change of dynasty he shaved his head, entered a monastic

order, and started life as a hermit. He wore coarse clothes and his food was simpler than that of the poorest scholar. He severed all his connections with the world, but when inspiring thoughts arose, he would express them in poems or paintings, and most of it was done according to the Ch'an mode, simply as self-expression without any attempt to make it intelligible to others. . . . He used a worn out brush and did not aim at likeness. He often said, 'Can you guess what it is? It is what Wu Tao-jen has made of nothing.' From these remarks it becomes evident that the meaning of his pictures was of Ch'an origin."[57]

In Japan itself, few of the outstanding modern artists show any Zen influence. This is partly because of the tremendous impact that Western oil painting has had on Japanese artists and partly because of the fact that the conservative painters who work in a traditional style look back to other phases of Japanese art such as Momoyama decorative screen paintings, Yamato-e narrative scrolls, or the woodblocks of the ukiyo-e. Among those who claim a Zen heritage, by far the most vital and original is Shiko Munakata, born in 1903, who both in style and in subject clearly reflects his Zen beliefs. Many of his prints as well as his ink paintings and calligraphies are definitely Zen in inspiration, showing Buddhist saints (Plate 51), abstract landscapes similar to those of the Ashikaga Zen painters, and calligraphic scrolls of Zen sayings. His manner of work is even more characteristic of the Zen approach. Charles Terry, in writing about Munakata, says, "As for his attitude towards art, he flatly answers that it is based on Zen Buddhism, and he firmly believes that true art should follow the Zen principle of selflessness. Too many artists, he has said, have too much self in their work."[58] To him creativity is something very natural, which springs spontaneously from the inner self. A few strokes, the brush moving with an astonishing, almost effortless speed, or a quick attack of the knife on the block, and the statement has been made, the truth revealed. Although his work is not Zen in a traditional sense, it gives expression to the same spirit that motivated

the Zen masters and shows the vitality of the Zen tradition even in the Japan of the modern world.

Today, Zen ideals are kept alive in Japan through the peculiar aesthetic sensibility developed by the tea masters. Their taste is the taste of the cultured Japanese with terms like *wabi* and *shibui* still the highest praise for works that show the subtle simplicity that continues to be admired. A modern painter like Kenzo Okada may not be a Zen Buddhist, and he may not even be affected by Zen on a conscious plane, but his subtle and infinitely sensitive pictures, with their subdued harmony and quiet, reflect a Japanese tradition that owes much to Zen (Plate 52). What is most remarkable is that the love for the natural and the unpretentious is not only found among the educated Japanese of the cities but is also the essence of the folk art that still exists in the isolated mountain villages of Kyushu and Tohoku. Here, as in the teahouses, the Zen spirit lives on, though with little awareness that this cult of simple beauty is ultimately indebted to the taste and ideas of the Zen monks of old Japan. Only the ever-present Daruma folk doll (Plate 53), a toy representing the founder of Zen as a legless roly-poly which always stands up whenever it is pushed over, suggests an awareness of the importance of Zen Buddhism even in the remote villages and towns of contemporary Japan.

Notes

1. E. R. Hughes, *Chinese Philosophy in Classical Times*, p. 144.
2. D. T. Suzuki, *Essays in Zen Buddhism*, first series, p. 167.
3. A. Waley, *An Introduction to the Study of Chinese Painting*, p. 215.
4. Suzuki, *op. cit.*, p. 212.
5. C. Eliot, *Japanese Buddhism*, p. 285.
6. A. Wright, *Buddhism in Chinese History*, p. 78.
7. C. Humphreys, *Zen Buddhism*, p. 26.
8. A. Coomaraswamy, *Buddha and the Gospel of Buddhism*, p. 233.
9. M. Wong, trans., *The Sutra of Wei Lang*, p. 32.
10. D. T. Suzuki, *Zen and Japanese Buddhism*, p. 36.
11. A. Waley, *Three Ways of Thought in Ancient China*, p. 39.
12. L. C. Goodrich, *A Short History of the Chinese People*, p. 85.
13. K. S. Latourette, *The Chinese: Their History and Culture*, Vol. I, p. 213.
14. E. O. Reischauer, *Ennin's Travel's in T'ang China*, p. 173.
15. A. W. Watts, *The Way of Zen*, p. 157.
16. W. T. de Bary, ed., *Sources of Japanese Tradition*, p. 253.
17. J. Blofield, trans., *The Zen Teachings of Huang Po*.
18. Watts, *op. cit.*, p. 157.
19. H. Henderson, *An Introduction to Haiku*, p. 21.
20. R. H. Blyth, *Haiku*, Vol. I, p. 241.
21. D. T. Suzuki, *Essays in Zen Buddhism*, first series, pp. 330–31.
22. *Ibid.*, pp. 371–76.
23. E. Herrigel, *The Method of Zen*, pp. 69–70.
24. O. Sirén, *Chinese Painting*, Vol. II, p. 138.
25. D. T. Suzuki, *Mysticism, Christian and Buddhist*, p. 32.
26. Kuo Hsi, *Essay on Landscape Painting* (translated by S. Sakanishi), p. 30.
27. Eliot, *op. cit.*, p. 284.

28. D. T. Suzuki, *Zen and Japanese Buddhism*, p. 35.

29. Blyth, *op. cit.*, pp. 12–13.

30. *Ibid.*, pp. 17–18.

31. I. Tanaka, *Liang K'ai*, introduction.

32. J. Cahill, *Chinese Painting*, pp. 8–10.

33. J. Covell, *Under the Seal of Sesshu*, p. 85.

34. A. Huxley, *Heaven and Hell*, p. 97.

35. A. L. Sadler, *Cha-no-Yu*, p. 102.

36. D. T. Suzuki, *Zen and Japanese Culture*, p. 283.

37. W. Blaser, *Japanese Temples and Teahouses*, p. 7.

38. L. Warner, *The Enduring Art of Japan*, pp. 96–97.

39. J. Harada, *Japanese Gardens*, p. 20.

40. Sadler, *op. cit.*, p. 111.

41. D. T. Suzuki, "Zen in the Modern World," *Japan Quarterly*, Vol. V, pp. 455–56.

42. R. Hawkins, "Contemporary Art and the Orient," *College Art Journal*, Vol. XVI, pp. 118–31.

43. W. Gropius, "Zen Palace: A Vanguard Concept," *Art News*, Vol. LIX, pp. 40–43.

44. W. Peterson, "Stone Garden," *Evergreen Review*, Vol. i, No. 4, pp. 127–37.

45. H. S. Hisamatsu, "Seven Characteristics of Zen Art," *It is*, No. 5, pp. 62–64.

46. K. Brasch, *Hakuin und die Zen Malerei*.

47. H. Brasch, "Zenga: Zen Buddhist Painting," *Oriental Art*, Vol. VI, pp. 58–63.

48. D. T. Suzuki, "Sengai, Zen, and Art," *Art News Annual*, 1958.

49. C. Roberts, *Mark Tobey*, p. 34.

50. *Ibid.*, p. 43.

51. F. S. Wight, *Morris Graves*, p. 19.

52. D. Miller, *Americans 1942*, p. 57.

53. W. Schmalenbach, *Julius Bissier: Farbige Miniaturen.*

54. Roberts, *op. cit.*, p. 10.

55. Hawkins, *op. cit.*, p. 131.

56. Warner, *op. cit.*, p. 101.

57. O. Sirén, *Chinese Painting*, Vol. V, p. 138.

58. C. Terry, "The Western Element in Munakata," *Japan Quarterly*, Vol. V, p. 42.

Bibliography

Blofield, J. (trans.): *The Huang Po Doctrine of the Universal Mind*, London, 1947

Blyth, R. H.: *Haiku* (4 vols.), Tokyo, 1949-52

——: *Zen in English Literature and Oriental Classics*, Tokyo, 1948

Brasch, H.: "Zenga: Zen Buddhist Painting," *Oriental Art*, Vol. VI, No. 2

Brasch, K.: *Hakuin und die Zen Malerei*, Tokyo, 1957

Coomaraswamy, A.: *Buddha and the Gospel of Buddhism*, London, 1915

Eliot, C.: *Japanese Buddhism*, London 1935

Grosse, E.: *Ostasiatische Tuschmalerei*, Berlin, 1923

Herrigel, E.: *The Method of Zen*, New York, 1960

——: *Zen and the Art of Archery*, London, 1953

Hisamatsu, H. S.: "Seven Characteristics of Zen Art," *It Is*, No. 5

——: *Zen and the Fine Arts*, Kyoto, 1958

Humphreys, C.: *Buddhism*, London, 1951

——: *Zen Buddhism*, London, 1949

Kuck, L. E.: *The Art of Japanese Gardens*, New York, 1941

Ross, N. W.: *The World of Zen*, New York, 1960

Sadler, A.: *Cha-no-Yu*, Kobe and London, 1933 (reprinted, Tokyo and Rutland, Vermont, 1962)

Seckel, D.: *Buddhistische Kunst Ostasiens*, Stuttgart, 1957

Sirén, O.: *Chinese Painting: Leading Masters and Principles*, New York, 1958

——: "Zen Buddhism and Its Relation to Art," *Theosophical Path*, October 1934

Suzuki, D. T.: *Essays in Zen Buddhism*, Series 1-3, London, 1949-51

——: *Introduction to Zen Buddhism*, New York, 1949

——: "Sengai, Zen, and Art," *Art News Annual*, 1958

——: *Zen and Japanese Buddhism,* Tokyo, 1958

——: *Zen and Japanese Culture,* New York, 1959

——: *Zen and the Doctrine of No-Mind,* London, 1949

Tanaka, I.: *Liang K'ai,* Kyoto, 1957

Waley, A.: *Introduction to the Study of Chinese Painting,* London, 1923

——: *Zen Buddhism and Its Relation to Art,* London, 1922

Watts, A. W.: *The Spirit of Zen,* London, 1955

——: *The Way of Zen,* New York, 1957

Wong Mou-lam (trans.): *The Sutra of Wei Lang,* London, 1944

Wright, A.: *Buddhism in Chinese History,* Stanford, 1959

Index

NOTE: *Numbers in italics indicate pages on which plates appear; all other numbers indicate text pages.*

A Mountain Village in Clearing Mist, 44–47, *56*, *57*
abbot's quarters, see *hojo*
abbot's residence, *115*
abstract calligraphy, 144
Amida, 25
Amitabha, 15, 31
Arhats, 32, 33, 38
Art News Annual, 142
Ashikaga college, 27
Ashikaga period, see Muromachi period
Ashikaga Shoguns, 26, 32, 39, 53, 56, 61, 66, 92, 93, 105, 130, 131
Ashikaga Takauji, 26
Ashikaga Yoshimasa, 26, 32, 92, 93, 130, 131
Ashikaga Yoshimitsu, 26, 39
Ashiya kettles, 99
Autumn Moon over Lake Tung-t'ing, 40

Bahai, 143
Basho, 29
beatniks, 141
Benedict, Ruth, 94
Bissier, Julius, 144
Bizen ware, 98; old Bizen tea bowl, *112*
Blaser, Werner, 106
Bodhidharma (Daruma), 14, 15, 17, 33, 38, *41*, *52*, 58, 59, 67, 68, 70, 71, 72, *95*

Bodhisattvas, 33
Bodhisattva of Mercy and Compassion, see Kannon
Bodhisattva of Wisdom, see Monju
Bokusai, 64, *77*
Book of Gardens, see *Emposho*
Book of Tea (Okakura), 91
Boston Museum, 59
Brahman, 16
Brasch, Kurt, 142
Buber, Martin, 16
Buddha hall, see *butsuden*
Buddha-nature, 14, 15, 53
Buddha of the Future, see Maitreya
Buddha of the Western Paradise, see Amitabha
Bukan, see Fêng-kan
butsuden, *102*, *103*

Caravaggio, 67
Catching a Catfish with a Gourd, 65, *78–79*
chado (way of tea), 101
cha-ire (tea caddy), 96, 97, 98
chajin (tea man), 92, 97, 99, 108
Ch'an (Dhyani, Zen), 13, 14, 16–20, 23–26, 31–39, 53, 54, 56, 58, 59, 61, 62, 65, 68, 146; origins of, 13–15; influence on Chinese culture, 20–21; introduction into Japan, 23–24
Chang Yen-yüan, 35

cha-no-yu (tea ceremony), 91, 92, 105, 106, 132, 133
chashitsu (tea house), 101, 107, 108, *118*, 132
chawan (tea bowl), 96
chien ware, see *temmoku*
Ch'ing period, 145
Ch'ing-chü (Ch'an teacher), 34
chinso (portraits of Zen masters), 63
Cho Densu, *see* Mincho
Chou period, 17
Chrysanthemum and the Sword (Benedict), 94
Chuang-tzu (Taoist), 19
Confucianists, 20, 21, 23
Confucianism, 28, 29
Coomeraswamy, Ananda, 17
cormorant, 71, *83*
cow-herding pictures, 34

Daigo-ji, 132
Daikyu (Zen priest), 71
Daio-o (Zen priest), 92
Daisen-in, *113*, *121*, 130, 131
Dai-Sojo (ecclesiastical title), 24
Daito Kokushi (Zen abbot,) 64, 89
Daitoku-ji, 37, 39, 64, 103, 108, *115*, 130, 133
Daruma, *see* Bodhidharma
Daruma, 86; doll of, *140*, 147
Daruma and Eka, as subject of painting, 67, 68
Dasoku, 69, *84*, *85*
densu (caretaker), 64
dhyana (contemplation), 14
Dhyani Buddhism, 13, 14, 16, 17, 67
Dharma hall, 103
Doan, 132
Dogen (Zen priest), 24, 25, 39
Dojinsai (tearoom), 92
doshaku-ga, 62
Doyu, *see* Ashikaga Yoshimitsu

Edo period, 28, 70, 71, 89, 97, 108, 132, 133
Egaku (Buddhist monk), 23
Eicho (compiler of *Zenrin Kushu*), 53
Eight Famous Views of the Hsiao and Hsiang Rivers, 40, 56
Eihei-ji, 25
Eiho-ji, 102

Eisai (Buddhist monk), 24, 25, 92
Eka, *see* Hui-k'o
Eliot, Charles, 16
Emposho, 127
Ennin, 20
Engaku-ji *or* Enkaku-ji, 26, 29, 102
Eno, *see* Hui-nêng
Essay on Landscape Painting (Kuo Hsi), 39
Evening Rain over Hsiao and Hsiang, 40

Fa-ch'ang, *see* Mu-ch'i
Fang I-chih (monk painter), 145
Fan-lung (Ch'an priest), 32
Fêng-kan, 58, 62, 63; and his tiger, 62, 73
Fishing Boats Returning to the Bay, 57
Five Great Temples, 26, 92
four principles of Sen-no-Rikyu, 106
Four Sleepers, 62, 73
Freer Gallery, 59, 63
Fudo Myo-o, 72
Fukurokuju, *88*, 89
Furuta Oribe (tea master), 133

gatha (sacred lines), 15
Gautama, see Sakyamuni
Geiami (court painter), 69
genkan, 104
Giku (Chinese monk), 23
Ginkaku-ji, 32, 92, 105, *116*, *122*, 131
Go-Daigo (Emperor), 26, 64
Golden Girdle, 53
Golden Pavilion, *see* Kinkaku-ji
Gozan, *see* Five Great Temples
Graves, Morris, 142, 143, 144
Grosse, Ernst, 144
Gropius, Walter, 108, 142
Gruppe Zen, 144

haboku style of painting, 69
Hagi ware, 98
haiga, 89
haiku, 29, 89
Hakata, 24, 89
Hakone Museum, 55
Hakuin (Zen priest), 18, 28, 72, *86*, *87*, 89, 142
Han period, 17
hanging scrolls, 35
Han-shan (Kanzan), 33, *50*, 55, 58, 62, 63
Harvest Moon over Tung-t'ing Lake, 57

hatto, see Dharma hall
Hawkins, Robert, 142
Hayafune, see Raku
Heiankyo (ancient Kyoto), 23
Hekiganroku, 128
Henderson, Harold, 29
Herrigel, Eugen, 36
Hideyoshi, 93, 96, 97
Hiei (Mount), 24, 25
Higashiyama, 131
Higashiyama collection, 32
Hinayana school of Buddhism, 13
Hotei, see Pu-tai
hojo (abbot's quarters), 103
Hojo clan, 24, 26
Hoseki Shinichi Hisamatsu (Zen abbot), 142
Hosokawa collection, 71, 72, 89
Hsia Kuei (Sung painter), 66, 130
Hsien-tzu, 63
Huang Kung-wang (Yuan painter), 59
Huang Po (Ch'an priest), 28
Hui-k'o (Ch'an priest), 14, 67, 68
Hui-k'o Offering His Arm to Bodhidharma, 81
Hui-nên (Sixth Patriarch), 14, 17, 28, 33, 54
Humphreys, Christmas, 17
Hung-jên (Fifth Patriarch), 19
Huxley, Aldous, 71

Ido ware, 97
Iga ware, 98
Ikkyu (Zen master), 64, 70, 77, 92
Imperial Academy of Hanchou, 53, 54
Indra, see Yin-t'o-lo
Ingen (Chinese monk), see Yin-yuan
ink painting, see *sumi-e* and *suiboku*
i-p'in style of painting, 31, 35
It Is, 142
Iwasaki family, 38
Izumo ware, 98

Jade Stream, see Yü-chien
Jasoku, see Dasoku
Jisho-ji, 131
Jittoku, see Shin-tê
Jo-fen (monk painter), 56
Jo-o (tea master), 93
Josetsu (priest painter), 65, 66, 78, 79
Joshu, 95

Jufuku-ji, 26

Kagoshima, 98
Kaisando, 102
kaiseki, 98
kakoi tearoom, 107
Kamakura, 26, 29, 102
Kamakura period, 24, 26, 27, 63, 92, 102, 104, 127, 128
Kanden Tea House, *124*
Kandinsky, 145
Kannon (Kuan Yin), 39, 40, 72; with the monkey and the crane, 33
Kannondo, 102
Kano school of painting, 70
Kano Masanobu, 70, 71
Kano Motonobu, 71
Kanzan, see Han-shan
Kansan, 74
Kanzan and Jittoku, 80
Kao (monk painter), 61, 62, 63, 67, 74
Karatsu ware, 98, *112*
Kara-yo style of architecture, 102, 105
Kasyapa (disciple of Buddha), 14
Kato Toshiro (Seto potter), 97
Katsura Detached Palace, 107, *125,* 132, 133, 142
Kei Shoki (Shokei), 69
Keijo Shurin, 69
Kencho-ji, 26, 69, 102
Kennin-ji, 24, 25, 26
Kenzo Okada, *139, 147*
Kinkaku-ji, 105, 132
Klee, Paul, 145
koan, 18, 25, 28
Kobori Enshu (tea master), 108, 133
Koetsu, 97
Kogetsudai (Moon-Viewing Terrace), 131
Koho-an (tearoom), 108, *118, 123, 126,* 133
koji (enlightened recluse), 93
Kokei Osho (Zen master), 93
koshikake (roofed wooden arbor), 133
Koto-in, *117*
Kozan-ji, 102
Kuan Yin, see Kannon
K'uo-an (Ch'an monk), 34
Kuo Hsi (Chinese essayist), 39
Kyoto, 23, 24, 25, 26, 27, 28, 32, 37, 61, 65, 71, 92, 97, 103, 104, 107, 108, 128, 132

Lankâvatâra-sutra, 16
Landscape, 82
landscape in four seasons, 68
Lao-tzu, 13, 16, 38, 39
Lassaw (American sculptor), 145
Liang dynasty, 14
Liang K'ai, 17, 33, *43,* 53, 54, 55, 56, 57, 63
Li Ao (disciple of Yao-shan), 58
Lin-chi (founder of Rinzai sect), 18, 24, 70
literati painters, 32, 59
Liu-t'ung-ssu (Ch'an monastery), 36, 53
Lohan, *see* Arhats

Maeda collection, 62
Magada in India, 58
Mahākāśyapa, 13
Mahayana school of Buddhism, 13, 17
Maitreya (Buddha of the Future), 34, 55, 62
Making of Hill Gardens, 129
Mampuku-ji, 28
Manchu dynasty, 59
mandalas, 33
Manessier, 145
Marin, John, 57
Ma Yuan, 33, 66, 130
Miidera, 25
Minamoto clan, 24
Mincho (monk painter), 64, *76*
Ming period, 20, 27, 28, 59, 67
Mitsu-an, 108
Miyamoto Musashi, *see* Niten
Mokuan (monk painter), 61, 62, 63, *73*
Momoyama period, 28, 70, 97, 106, 132, 133
Mondrian, 145
Monju, 39, 40, *138*
Monkeys, 42
Moon-Viewing Terrace, *see* Kogetsudai
Mori scroll, 68
mu, 18
Mu-ch'i, *2,* 33, 36, 37, 38, 39, 40, *41, 42,* 55, 57, 62, 145
Munakata, *138,* 146
Munch, 89
Murayama collection, 55
Muromachi period, 26, 27, 28, 63, 70, 92, 101, 102, 104, 105, 108, 131
Muso Kokushi *or* Soseki, 26, 64, 75, 128

Muto Shui (priest painter), 64, *75*
Myoshin, 65, 71

Nagao collection, 63, 71
Nagoya, 57, 98
Nambo-roku (Sokei), 95
nanga style of painting, 70
Nanzen-ji, 27, 69
Nara period, 23
National Museum of Tokyo, *see* Tokyo National Museum
Nichiren, 25
nijiriguchi (tearoom entrance), 107
Niten, 71, *83*
Ni Tsan (Yuan painter), 59
Noami, 27
Nobunaga, 93
Noh theater, 27
Nolde, 89

Obai-in, 64
Obaku (Zen sect), 28
Ogura collection, 68
Oguri Sotan (tea master), 133
Ohara collection, 62
Okada Kenzo, *see* Kenzo Okada
Okakura, 91
Okyo school of painting, 70
Omote-Senke-ryu, 93, 133
Oribe ware, 98, *111*
Oriental Art, 142
Osaka, 66

Pang Chü-shin (Zen layman), 19
Paradise scenes, 33
Pe-ta Shan-jen (painter), 59
Patriarch Hui-nêng Tearing up the Sutras, 43
Pavilion of the Rustling Pines and the Sound of the Lute, *see* Shokintei
persimmons, *2,* 37, 38, 145
Petersen, Will, 142
Pi-yen-lu, see Hekiganroku
p'o-mo style of painting, *see* spilled ink
portraits of Zen masters, *see chinso*
prajna (supreme wisdom), 14, 17, 18
Pu-tai (Hotei), 34, *43,* 54, 55, 58, 62, 66, 67, 70

Ragara, 138
Raku, 97; *Hayafune, 109; Shunkan, 110*

Reading in a Hermitage in a Bamboo Grove, 66
Reiunin hall, 71
Rikyu, 92, 93, 94, 95, 96, 97, 98, 106, 107, 108, 132, 133
Rinzai (Zen sect), 18, 24, 27, 28, 29 72
Rinzai, Daruma, and Tokusan, 84, 85
Roberts, Collette, 143
roji, 95, 107, 132; see also *sotoroji*
Rokuon-ji, 132
roshi, 29
Ryoan-ji, *119, 120,* 129, 130, 131, 134, 142
Ryuko-in, 108

sabi, 95
Sadler, Professor, 94
Saiho-ji, 128
Sainen-ji, 67, 68
Sakai collection, 54, 55
Sakyamuni, 13, 15, 33, 63, 72
Sakyamuni as an Ascetic, 70
Sakyamuni Descending from the Mountain of His Awakening, 54
Sambo-in, 132
sammon (main gate), 103
sariras, 34
satori, 17, 18, 29, 69, 71
Satsuma ware, 98
seiji (celadon), 97
Seikado museum, 38
Sen-ami, 93
Sengai (Zen master), *88,* 89, 142
Sen-no-Rikyu, see Rikyu
Sesshu, 27, *57,* 65, 67, 68, *81, 82*
Seto, 97, *109*
Shaka, see Sakyamunim
Shariden, 102, *114*
shibui, 147
Shigaraki ware, 98
Shih K'o, 31, 32
Shih-t'ao (painter), 59
Shih-tê (Jittoku), 33, *50,* 55, 62, 63, 66
Shiko Munakata, see Munakata
Shimojo collection, 68
shinden-zukuri, 104, 105
Shingon sect, 23
Shinju-an, 133
Shino ware, 97, *111*
Shinto building, 101
Shintenno-ji, 66
Shobo Genzo Zuimonki (Dogen), 25

Shofuku-ji, 89
Shoichi Kokushi **(founder of Tofuku-ji),** 64, *76*
shoin, 104, 105, 130
shoin-zukuri, 104
shoji, 104
Shokei, see Kei Shoki
shoki (secretarial office), 69
Shokintei, 107, *125*
Shokoku-ji, 65, 67
Shomu (Emperor), 92
shrike by Niten, 71, 72
Shubun (priest painter), 27, 65, 66, 67, *80*
Shunkan, see Raku
Shuko (tea master), 92, 106
Silver Pavilion, see Ginkaku-ji
Soami (painter), 129
Sokei, 95
sometsuke (blue-and-white ware), 97
Sotatsu-Korin school of painting, 70
Soto sect, 25, 33
sotoroji, 133
spilled ink style of painting, 35, 56, 69
suiboku (water-and-ink), 63, 64
sumi-e (ink painting), 27, 63, 68, 70, 96, 129
Sumitomo collection, 62
Sung period, 20, 21, 24, 32, 34, 36, 56, 58, 61, 64, 65, 66, 67, 102
Sunset over the Fishing Village, 40
Sutra of Wei Lang, 17, 28
Su T'ung-po, 32
Suzuki Daisetz, 29, 37, 39, 141, 142

Taigaku Shusu, 65
Taizo-in 65
Takauji, see Ashikaga Takauji
Tamba ware, 98
T'ang period, 14, 19, 20, 31, 33
tana (shelves), 104, 105
Tan-hsia (Ch'an priest), 34, 58
Tan-hsia Burning the Buddha Statue, 48–49
Tanka, see Tan-hsia
Tao, 13, 16, 19, 95, 144
Taoism, 17, 29
Taoists, 20, 21, 23, 39, 53, 65, 66
tatami, 96, 105, 107
tea bowl, see *chawan*
tea caddy, see *cha-ire*
tea ceremony, see *cha-no-yu*

tearoom, see *chashitsu*
tea utensils, 98, 99
temmoku, 97, *110*
Tendai sect, 23, 24
Tenryu-ji, 26, 128
terakoya, (temple school) 27
Terry, Charles, 146
Tĕ-shan, 70
T'ien T'ai, 24, 63
T'ient-t'ung, 67
Tobey, Mark, 142, 143, 144
Tofuku-ji, 26, 64, 134
Togudo, 92, *113*, 105
Toji-in, 132
toko, see *tokonoma*
tokonoma, 96, 104, 105, 107
Tokugawa, 28, 71
Tokugawa Museum, 57
Tokusan, see Tĕ-shan
Tokyo, 66
Tokyo National Museum, 54, 57, 58, 66, 69
Treasure of the Eye of the True Doctrine, see *Shobo Genzo Zuimonki*
Ts'ao-tung, see Soto
Tsugaru collection, 66
Tsukiyama Teizo-den, see *Making of Hill Gardens*
Tung-shan (founder of Soto sect), 33

Ueno collection, 63
Uji, 28, 92
ukiyo-e, 70, 145
Universal Mind, 28
Upanishads, 16
Ura-Senke-ryu, 93, 133

Van der Rohe, Ludwig, 168
Venice Biennale, 144
Vimalakirti, 58, 72
vinaya, 28

wabi, 95, 96, 107, 147

wall paintings, 35
Wang Meng (Yuan painter), 59
Warner Langdon, 127, 145
water-and-ink, see *suiboku*
Waterfall at Lu-shan in Mist, 57
Watts, Alan, 16, 20, 143
Way of Zen (Watts), 143
Wen-chu, see Monju
Wright, Arthur, 16
Wright, Frank Lloyd, 108
wu, see *mu*
Wu (Emperor), 14
Wu-chun (Ch'an abbot), 33
Wu-tai (Mount), 39
Wu Tao-jen, 146
Wu-tsung (Taoist Emperor), 20

Yamato-e, 146
Yao-shan (Zen patriarch), 58
Yen Hui (painter), *51*, 59
Yellow Plum Mountain, 19
Yin-t'o-lo, 34, *48*, *49*, *50*, 58, 62
Yin-yuan (Ingen), 28
Yoriie (Shogun), 24
yoritsuki, 133
Yoshikawa collection, 56, 57
Yoshimasa, see Ashikaga Yoshimasa
Yoshimitsu, see Ashikaga Yoshimitsu
Yuan period, 20, 58, 59, 64
Yü-chien, *44–47*

zazen, 25
Zen: origin of, 13–15; essential features of, 15–19; development in Japan, 24–26; influence in Japan, 27–29; temple plan, 103; see also Ch'an and Dhyani
Zen and Japanese Culture (Suzuki), 29
Zen and the Fine Arts (Hisamatsu), 142
zendo, 19, 102, 103
zenga, 72, 89
Zen Monk in Meditation, 51
Zenrin Kushu (Zen anthology), 53